JUNK

JUNK
AMERICA IN RUINS
DANNY LYON

Roadmaster Riviera: Danny Lyon at the Wheel

by Randy Kennedy

"On three sides his horizon was mountains of wrecked cars. Every possible kind of car in every possible kind of attitude: upside-down, sideways, on end, pitching, yawning, tilted. The ground under his feet was not ground at all but an unknowably thick layer of glass shards, glass of all colors, rose, yellow, clear, tinted blue and pink, and even black. Mixed with the glass were ragged slivers of aluminum, scarred lumps of cast iron, and other pieces of metal worn down as fine as sand. From long practice, he walked evenly over the uneven pieces of metal and glass."

—from *Car*, by Harry Crews, 1979

When I was a child in rural West Texas, my father would sometimes take my brother and me out with him to the junk yards that lay at respectful distances from town on the flatlands running east into New Mexico. These ragged boot hills, where wrecked cars were slowly turning the rust-brown color of the land under the ruthless laser beam of the sun, were for him some holy combination of carnival midway and pawn shop, places where a keen eye and a little haggling could score him an oil pan or carburetor valve for a fraction of the parts-store price. To my knowledge, my father took one of our cars to a mechanic only twice, when confronted with a kind of breakdown absolutely beyond his abilities; we were the family that never paid for a thing to be done that we could do ourselves.

What I remember mostly from those visits is towering heat and boredom, the sunshine splintering off broken windshields into my eyes, the spiders that collected inside the

black troughs of old tires. I also remember morbid curiosity: Did anyone survive the impact that caused that Cutlass Supreme to look that way? Did a human body travel through the human-sized hole in that windshield and, if so, how far did it go? What was required to remove the driver from the eight inches of space remaining between the dashboard and the Nappa leather bucket seat of that disfigured burgundy Mustang? I thought about how happy and proud these cars had probably once made someone—the places they'd gone, the music they'd listened to with the windows rolled down, the pictures they'd had of themselves behind the wheel, the people they'd kissed or fucked inside them (I was too young to really know about this but I intuited it from the bed-sized back seats; as Terry Allen sings in his great road song *Amarillo Highway:* "There's a girl in her bare feet/Asleep on the back seat/And that trunk's full of Pearl and Lone Star.")

Derelict houses eventually crumble or get demolished, but chassis and chrome can live on for decades in salvage, constituting enormous open-air exhibitions of American power and loss. Particularly in the West, where cheap real-estate is plentiful, scrapyards can sprawl over dozens of acres, football fields of picked-clean cars, industrial-material limbo-lands, immense not-quite trash heaps.

Walking among the rows of wreckage is like visiting a sculpture garden built with no sense of pacing or proportion; everything comes at you in cranked-up profusion. The colors are slightly more considered, often accentuated by what Donald Judd, writing about John Chamberlain's car-metal pieces, described as "the hard, sweet, pastel enamels, frequently roses and ceruleans, of Detroit's imitation elegance for the poor." These midcentury factory colors are then bleached and rusted and sandblasted into thousands of shades of painterly decay.

Danny Lyon's interest in such places involves at least a degree of nostalgia for the classic cars of his youth, manufactured during Detroit's golden age and the reign of Harley J. Earl, who marketed the fantasy of the racetrack to the suburban householder ("Win on Sunday, sell on Monday.")

But as both symbol and fact, a junkyard is the kind of terrain that has attracted Danny's gaze since he first became an artist, taking up the camera and the pen in the late 1960s. Naturally drawn to places where people or things are banished or condemned or exile themselves, willingly or not, he has made his most important bodies of work in removes: prisons, segregated cities, poverty-stricken neighborhoods, outlaw gangs, trans bars. By the time he made the pictures that comprise his powerful 1969 collection *The Destruction of Lower Manhattan*, a portrait of old neighborhoods being razed to make way for the World Trade Center and other

so-called urban improvements, his feeling for the ill-fated and the irretrievable was already fully formed, shaped by a deep distrust of mainstream American ideals like progress, efficiency and virtue.

"The passing of buildings was for me a great event," he wrote in the book's introduction. "It didn't matter so much whether they were of architectural importance. What mattered to me was that they were about to be destroyed. Whole blocks would disappear. An entire neighborhood. Its few last loft-occupying tenants were being evicted, and no place like it would ever be built again."

The automotive and the road have been abiding subjects, maybe in part because of Danny's itinerant existence for many years, living between Manhattan, upstate New York and central New Mexico. In the mid-1980s in Ulster County, New York, he embedded himself in the demolition-derby scene in the working-class Shawangunk Mountains and saw in the derbies, as he had in the motorcycle gangs of his classic *The Bikeriders*, places of fugitive inclusion that he wanted to understand and temporarily join.

"Only drivers and their oil-spattered mechanics were allowed into the pits," he wrote. "I wore my pit pass—often a human skull stamped on the back of my hand in red ink or a card worn around my neck—with pride. Stinking of gasoline and burning clutches, dedicated to doomed and dying cars, the pits were both a place of honor and as low a spot as you could find."

One of the things that has always made Danny's work powerful and compellingly unpredictable for me is his ability to hold contradictory ideas in his mind—in fact, not only to hold them but to find the profoundly, painfully human in their incongruity. As he and Nancy, his wife, wandered America in their Tesla looking for seductive junkyards, I can almost hear him ranting about the thousands of wrecks along their route as a shameful testament to a century of wanton pollution, the physical predicate to the planet's nosedive toward uninhabitability. Then I can see him getting out of the car and wandering through the yards during the golden hour, exulting in the surfaces and shapes and endless accidents of physical beauty that his eye can't help but find, whether in a civil-rights battle or a Chicago tenement or a filthy Houston tattoo parlor.

He wrote to me in December 2023 telling me he was nearing the end of a long, confidential photo project, swearing me to secrecy, asking me to write this essay about it. He ended the email with a sly come-on masquerading as a confession: "I don't do this often: make new pictures. I haven't in a decade or more. But when the bit gets in my mouth and an old Ford hits me in the flank … then I take off. I'm absolutely crazed by what I'm doing. I'm in heaven."

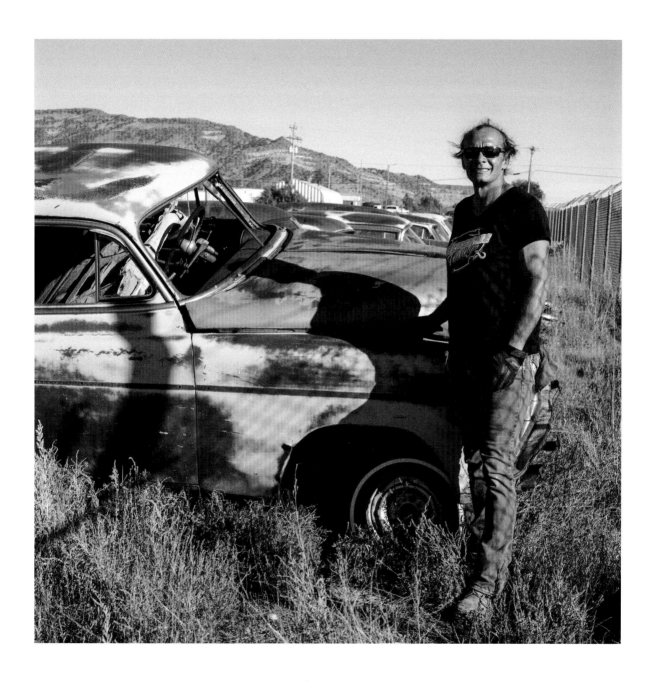

Leeann, Near Grants, New Mexico

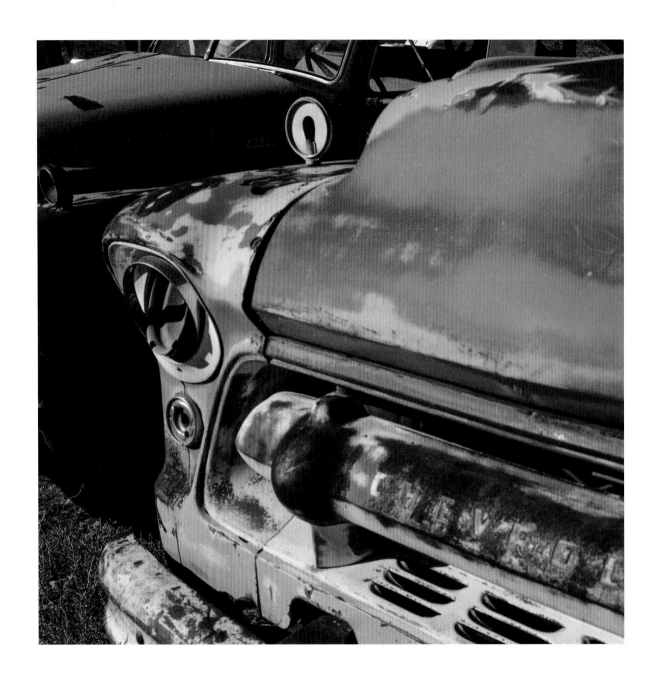

1957 Chevrolet Series 6400 Two Ton Truck

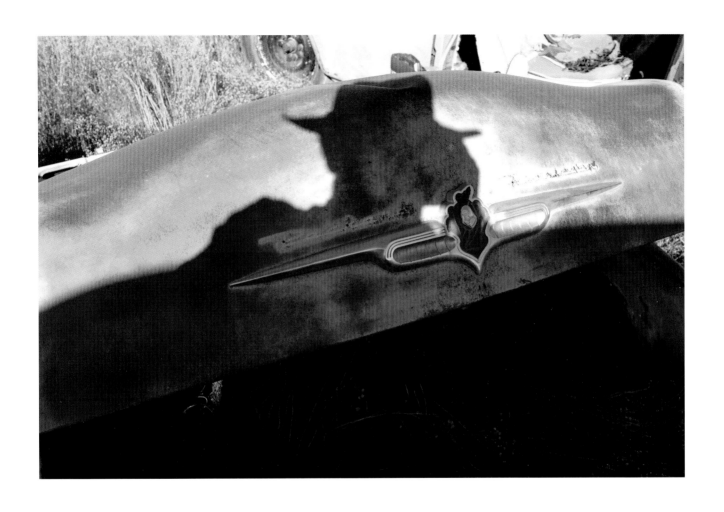

1954-55 Packard Patrician

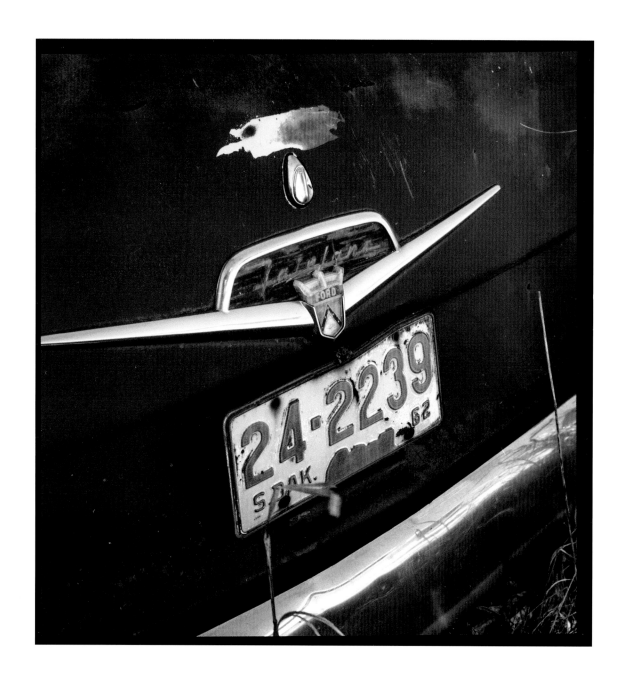

1956 Ford Fairlane

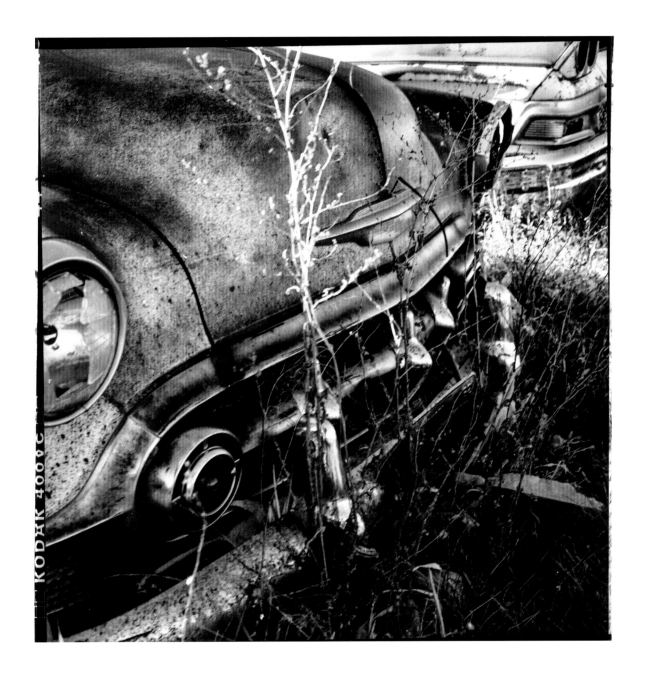

1953 Chevrolet Bel Air

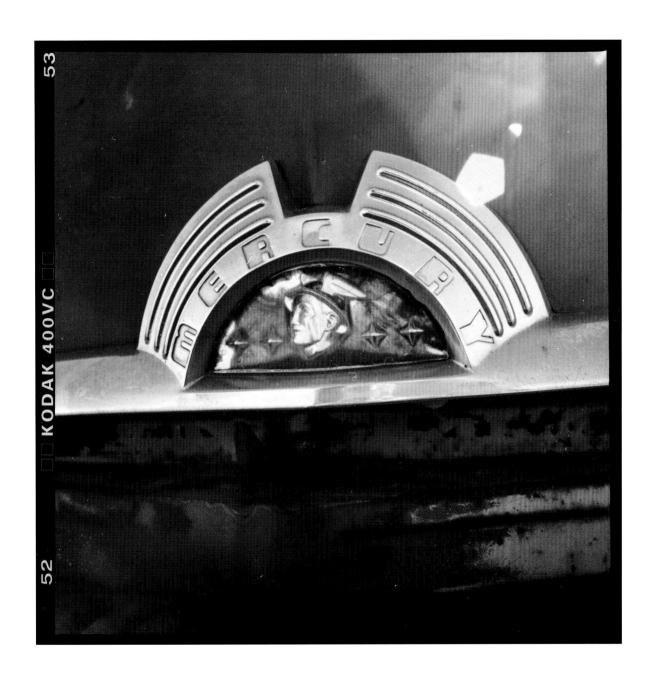

1951 Mercury Sedan

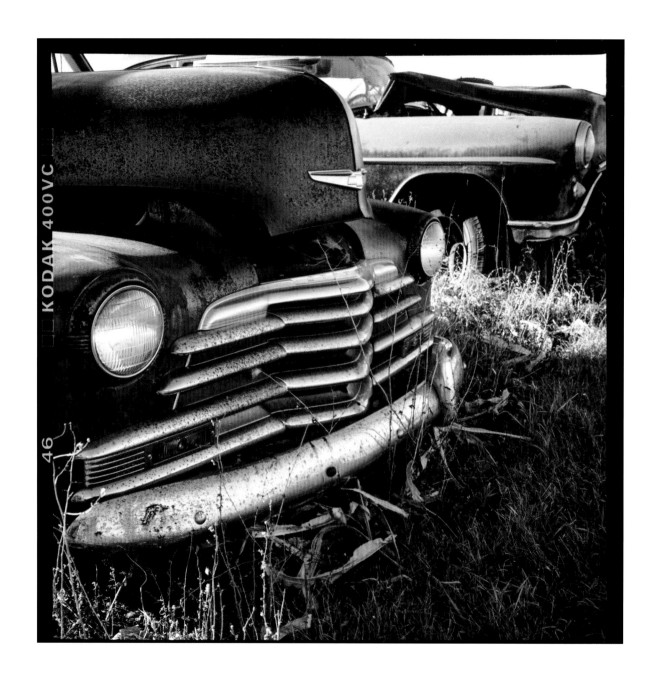

1947 Chevrolet Fleetline

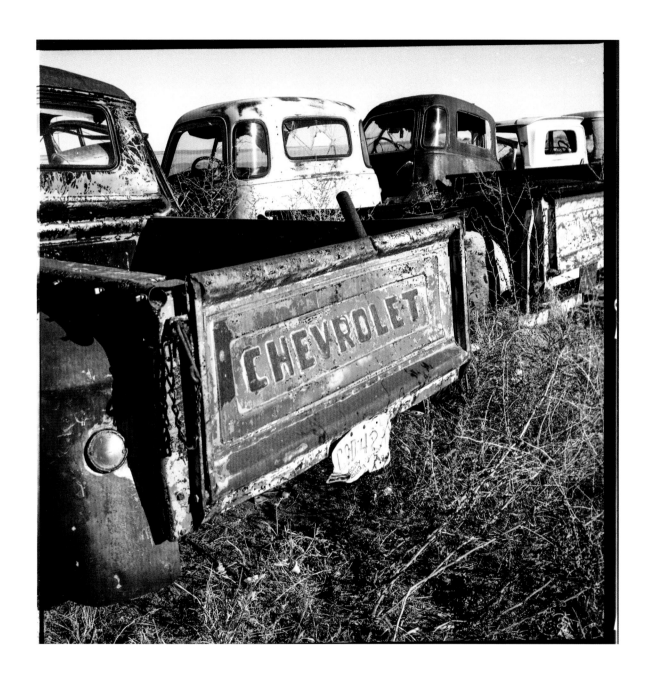

1950s Chevrolet Pickup

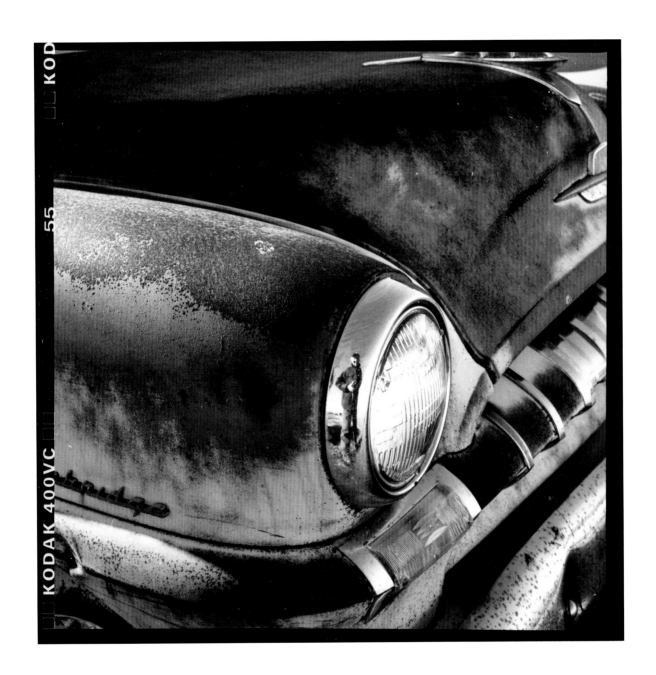

1953 Plymouth Cambridge

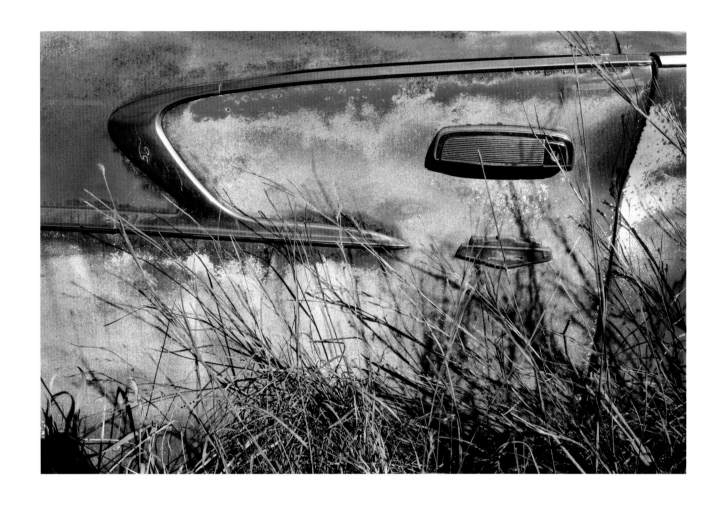

1961 Chrysler Newport

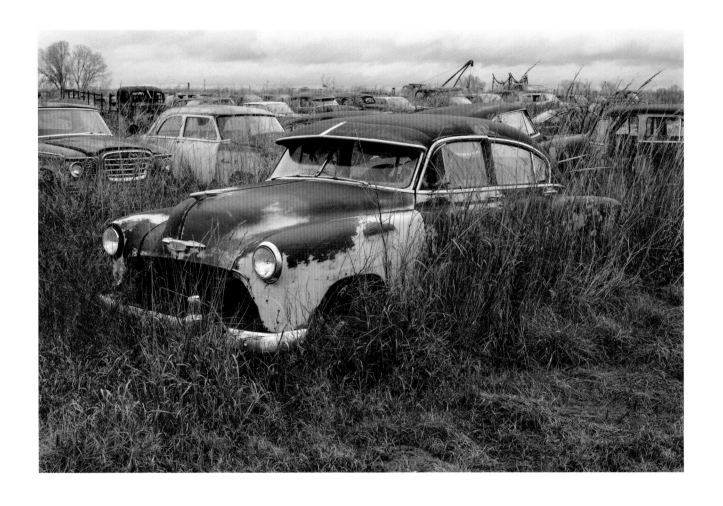

1951 Chevrolet Styleline

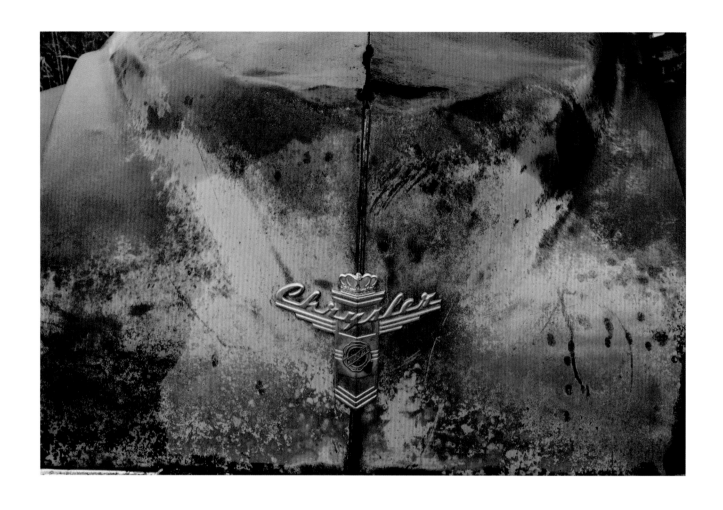

1946-48 Chrysler Windsor Coupe

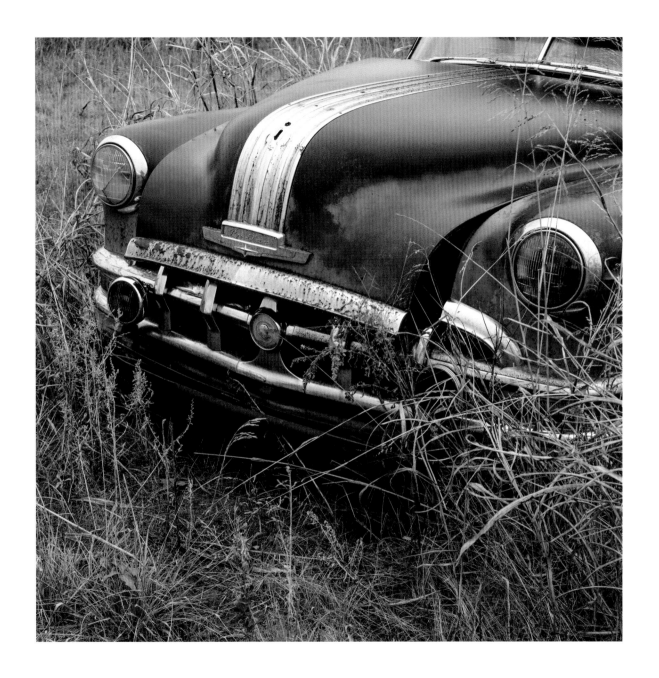

1950 Pontiac Chieftan

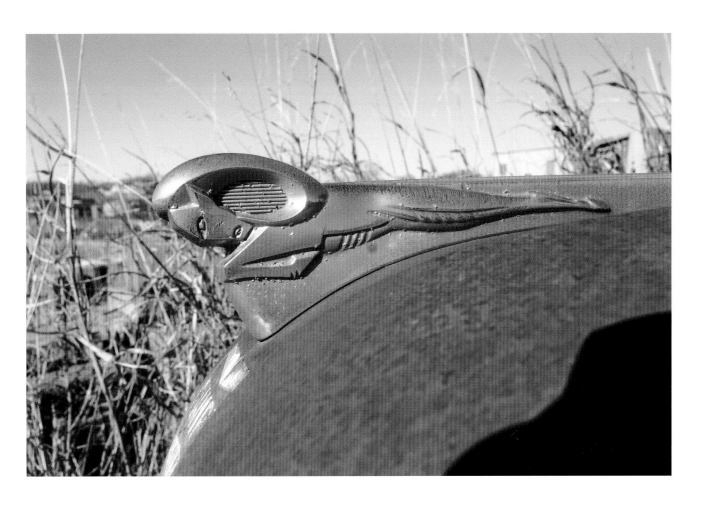

Early 1950s Dodge

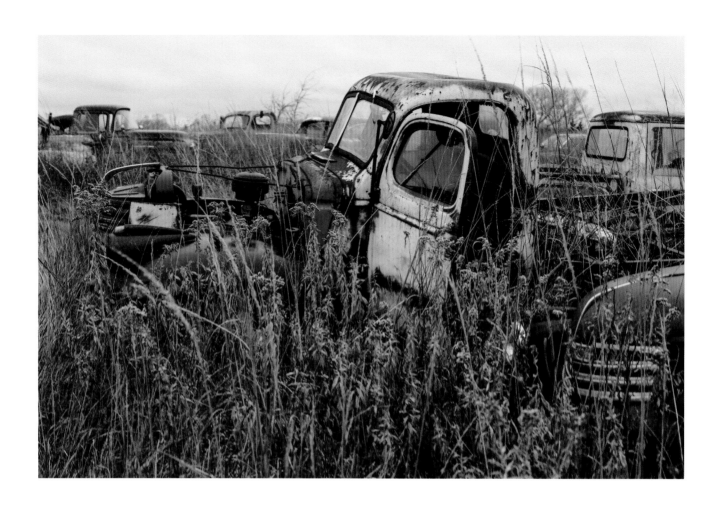

Early 1940s Chevrolet Pickup

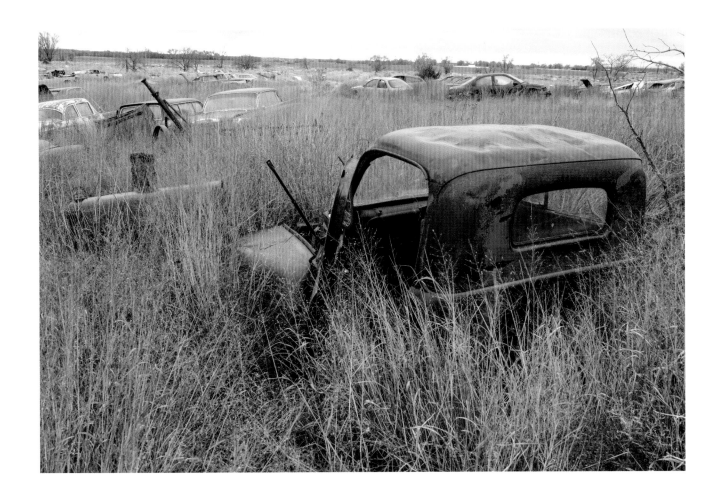

1949-50 Ford F-100

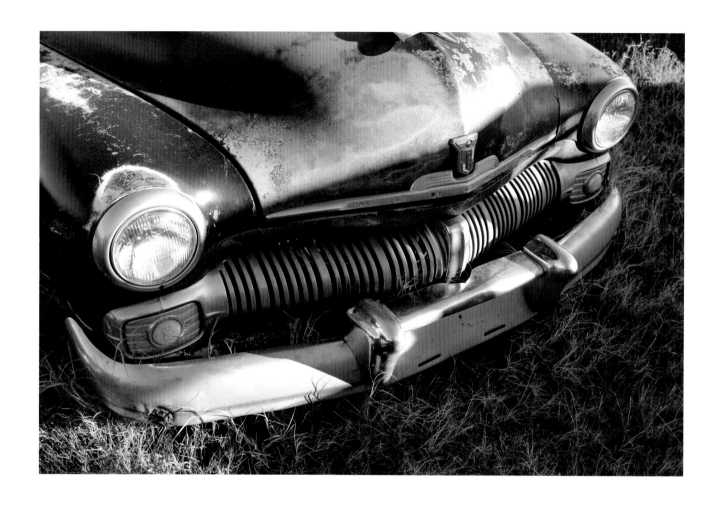

1950 Mercury Club Coupe

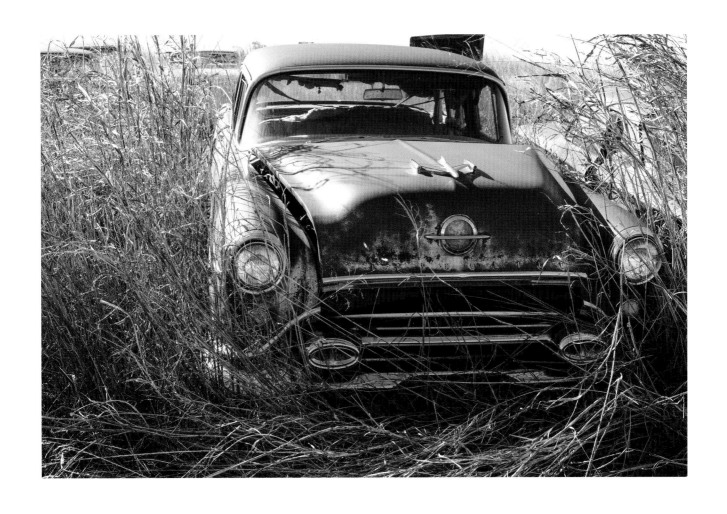

1954 Oldsmobile 88 Four Door Sedan

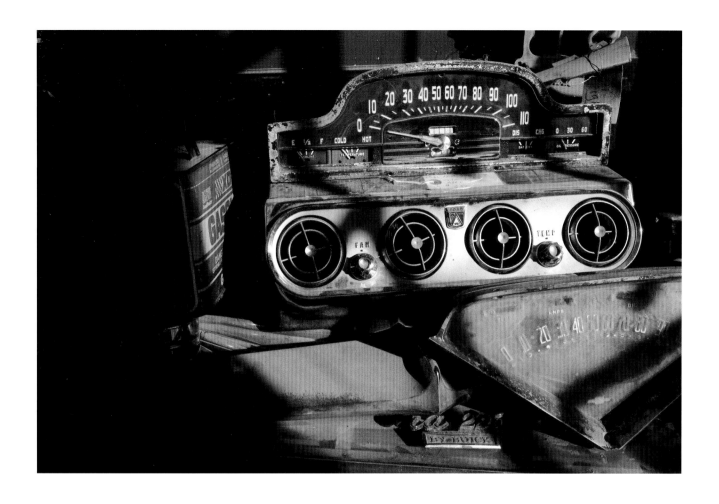

Top: 1949-50 Cadillac Speedometer
Middle: 1965 Ford Mustang A/C unit
Bottom Right: 1950s Chevrolet Truck Speedometer

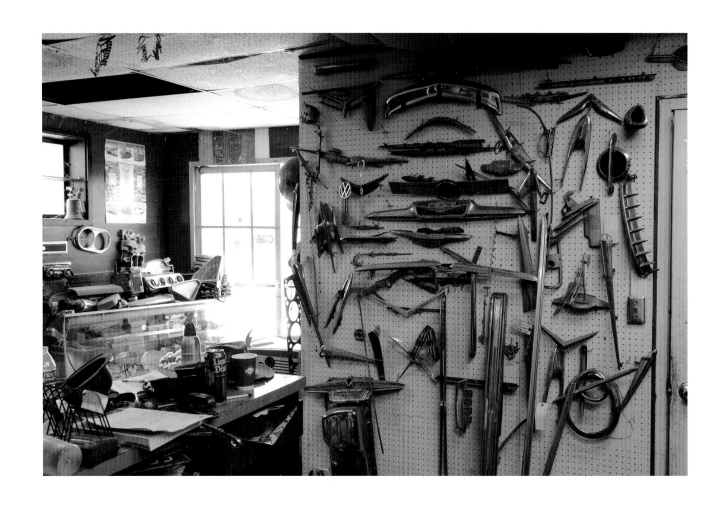

Junkyard Office Interior

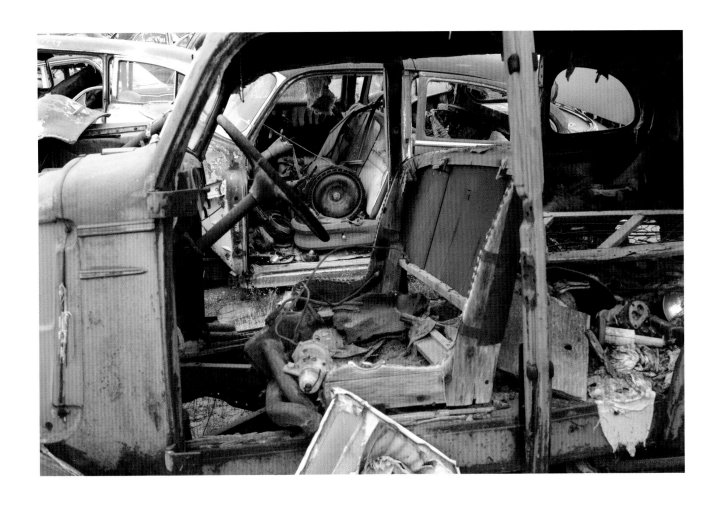

Interior of a Late 1930s Four Door

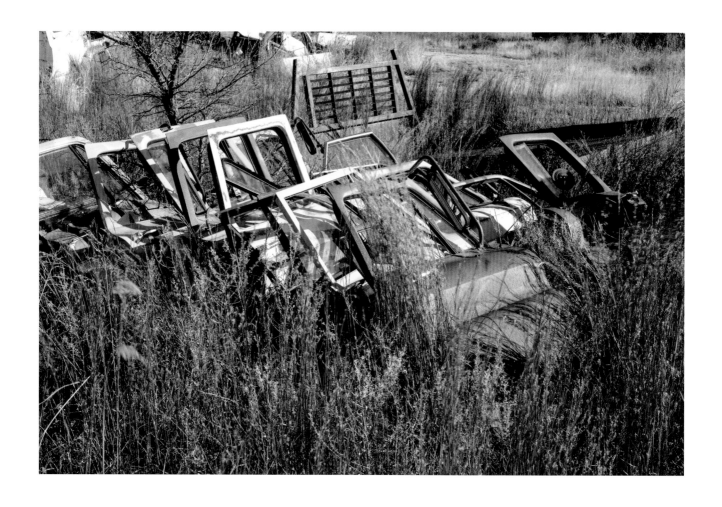

Ford Truck Doors

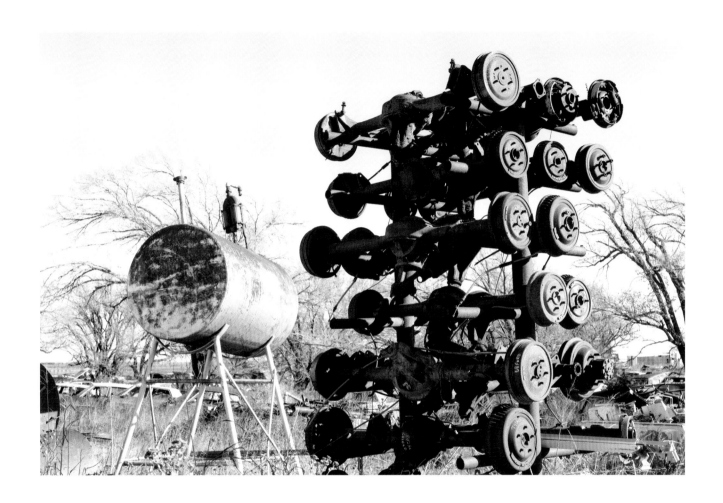

Axle stack

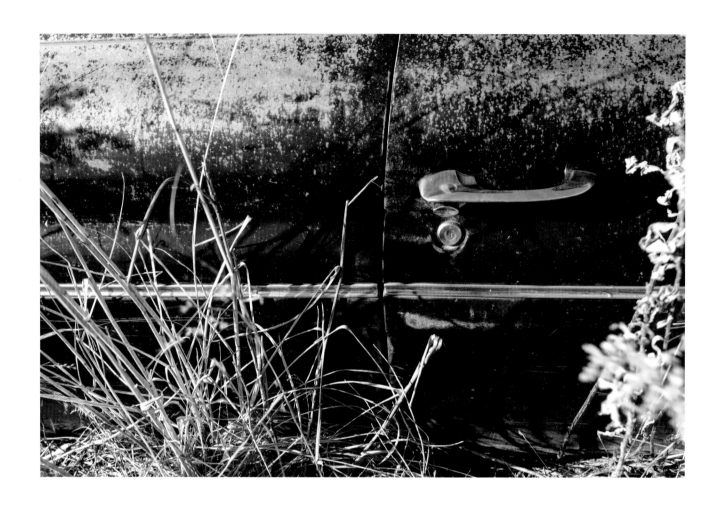

1950 Mercury Club Coupe

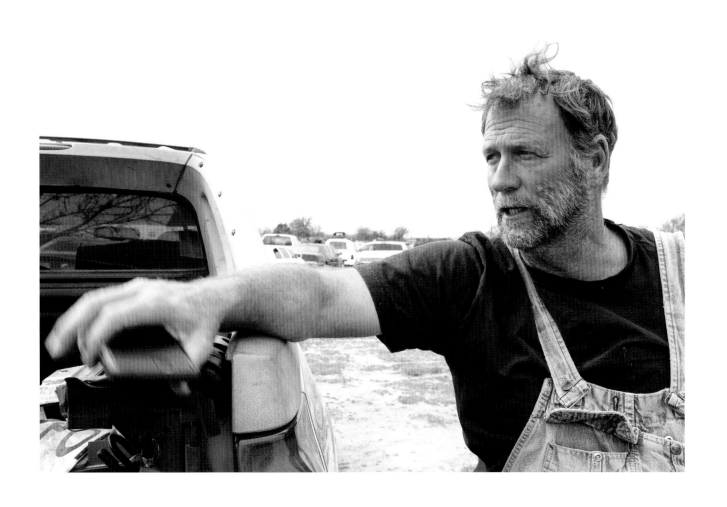

Trenton, Junkyard Owner, Central Texas

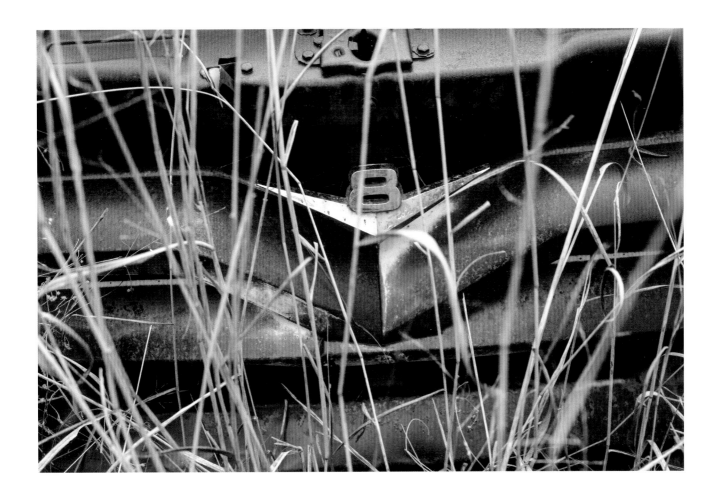

1956 Ford F-100

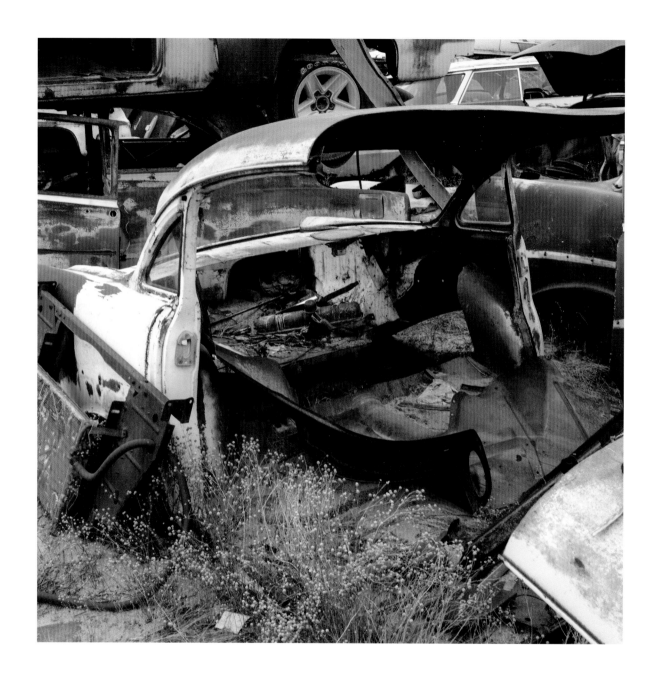

1950s Shell

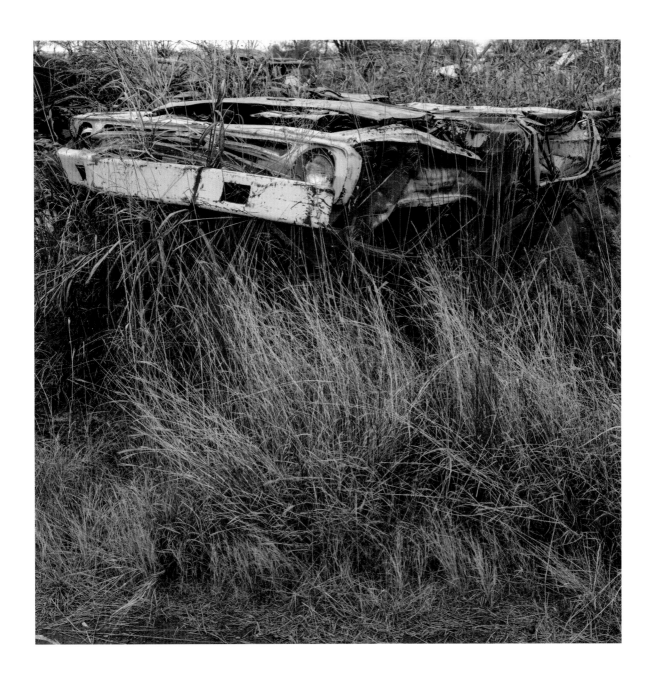

1972 Dodge

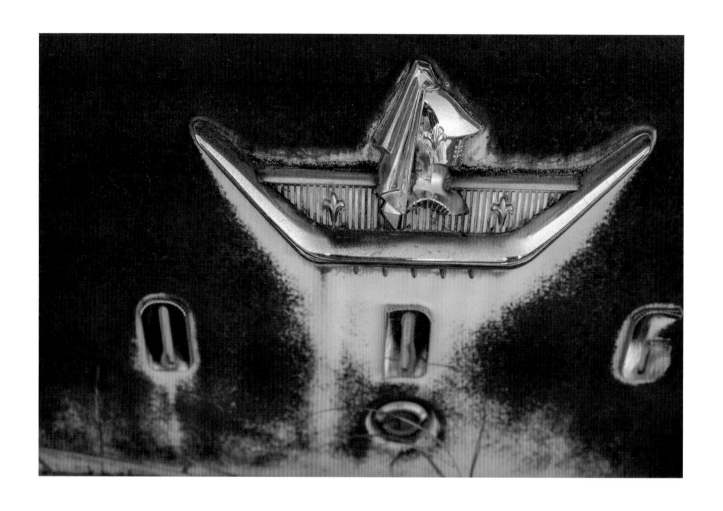

1959 Dodge Coronet

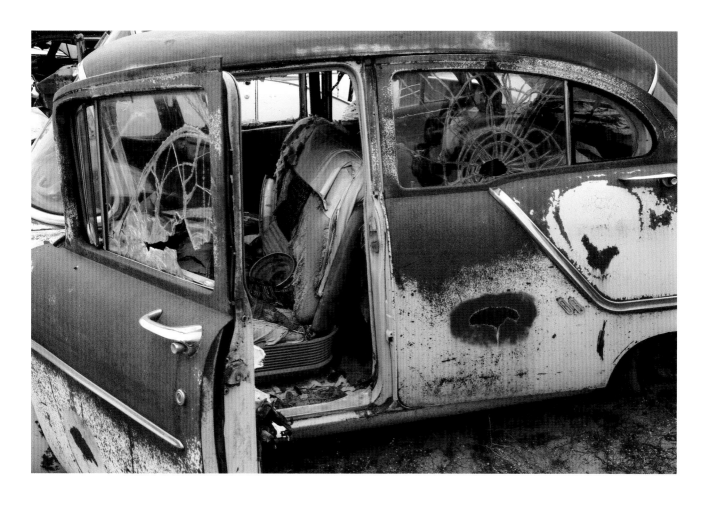

1954 Oldsmobile 88

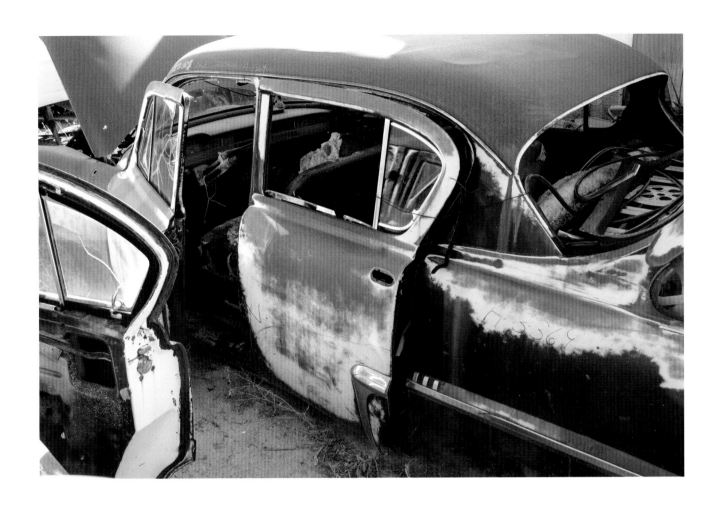

1953 Plymouth Cranbrook

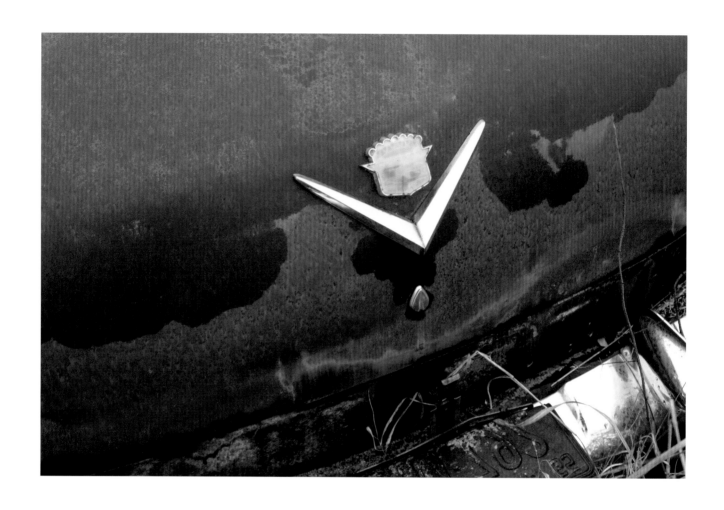

1951 Cadillac Series 62

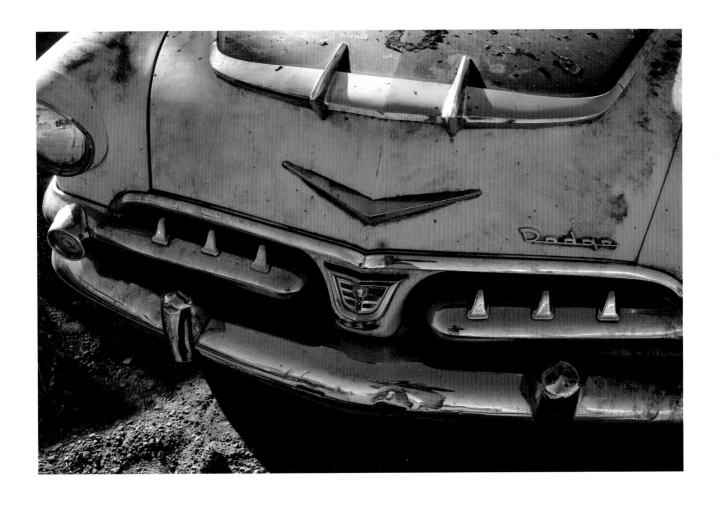

1956 Dodge Custom Royal

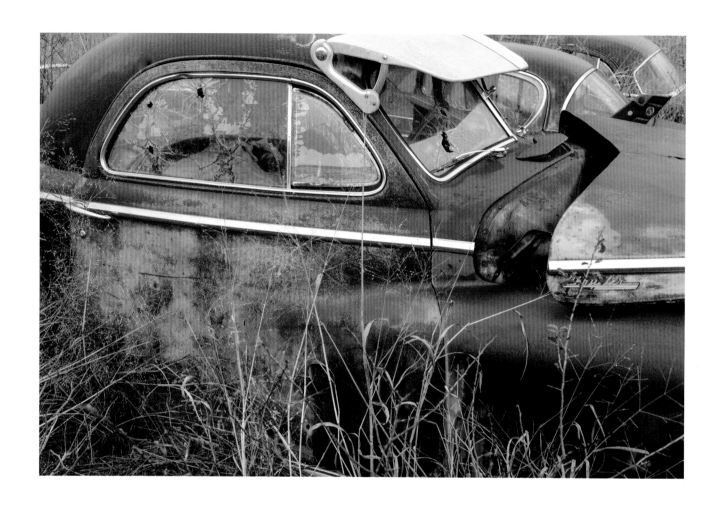

1946-48 Chrysler Windsor Coupe

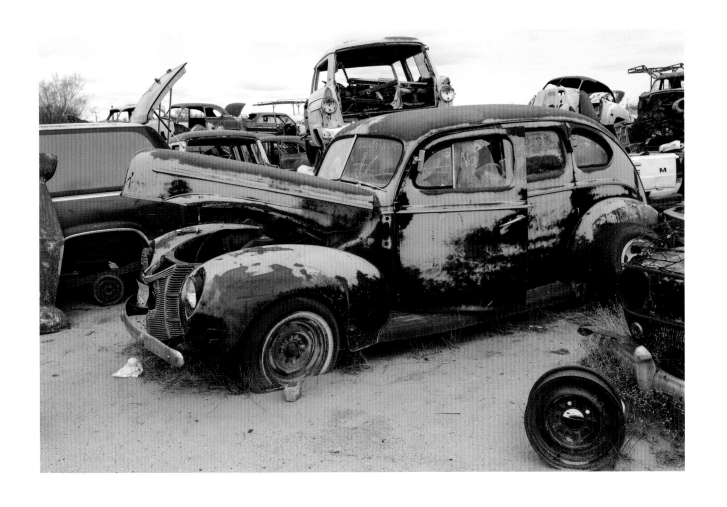

1940 Ford Fordor

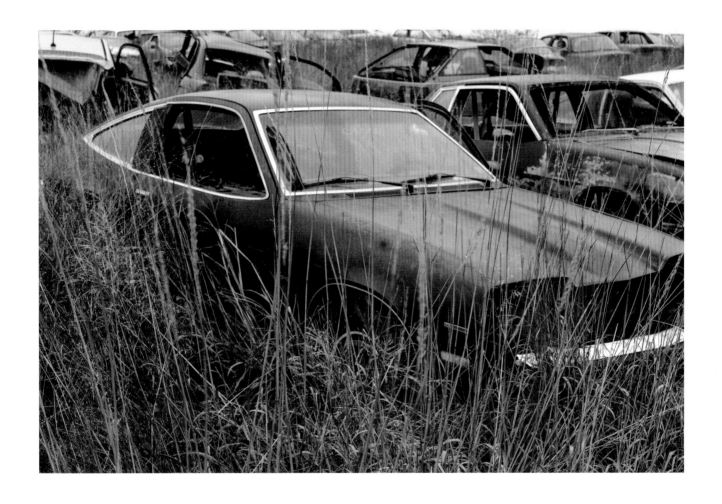

1975-80 Chevrolet Monza 2+2

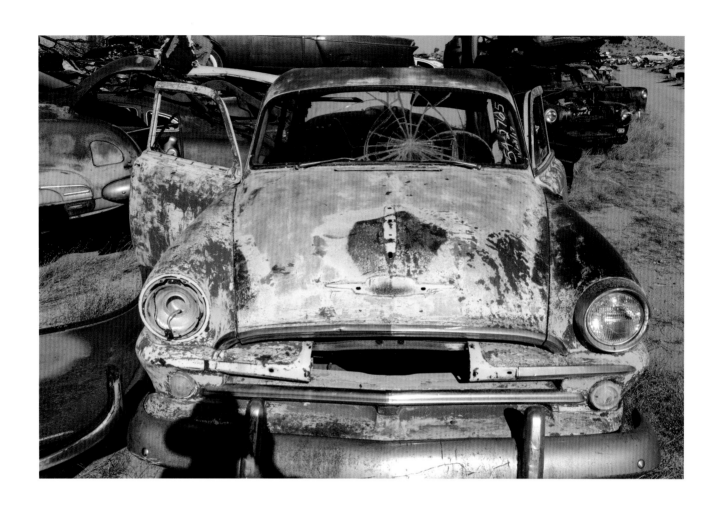

1954 Plymouth Belvedere

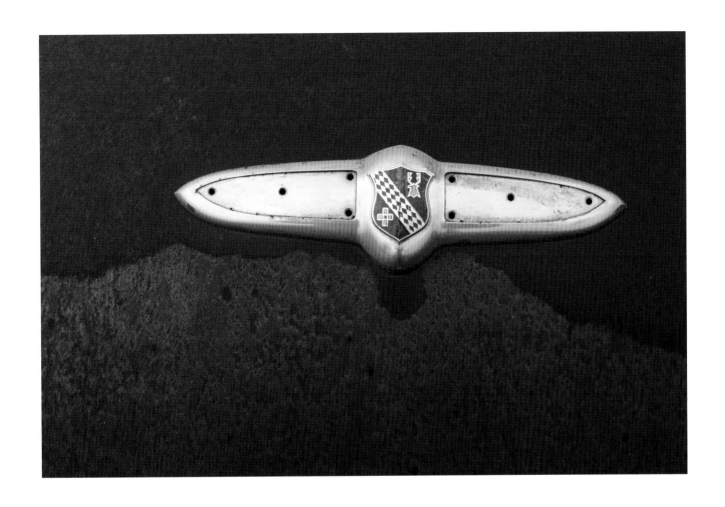

1942-1946 Buick

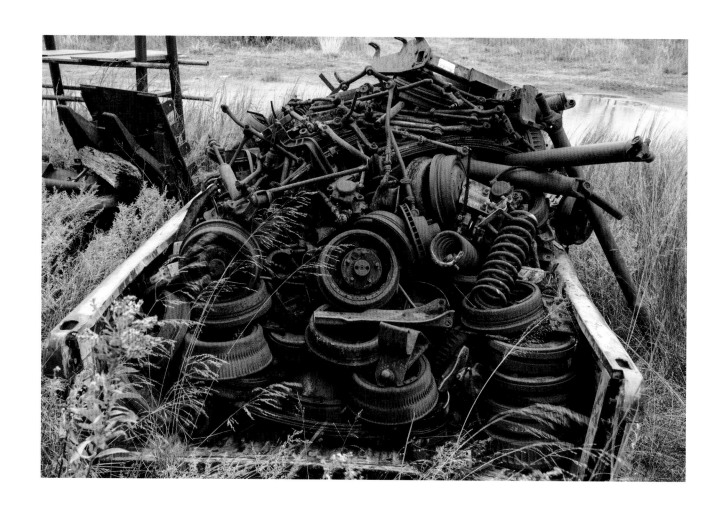

Rims, Tie Rods, Drive Shafts, and U-Joints

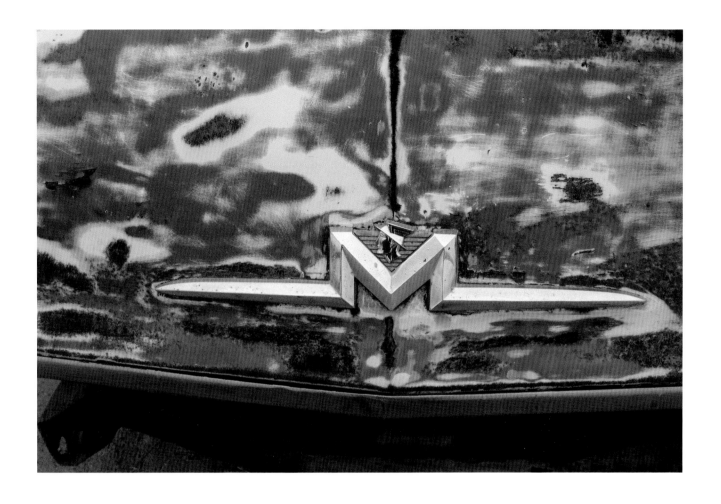

1950s Mercury

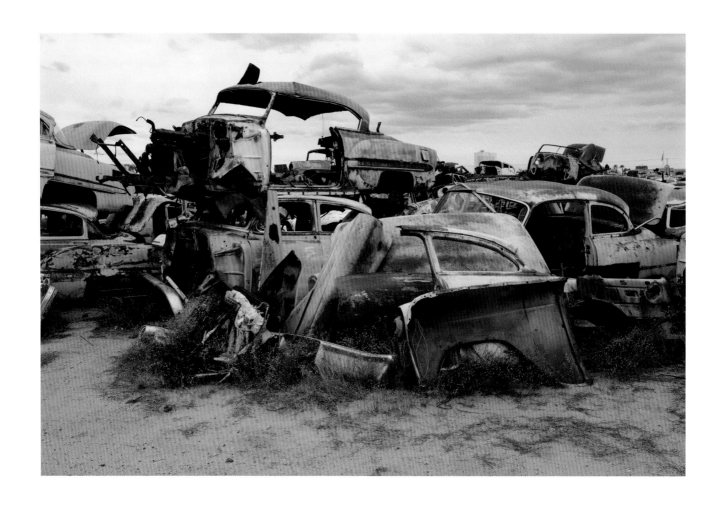

1954 Chevrolet Bel Air Shells

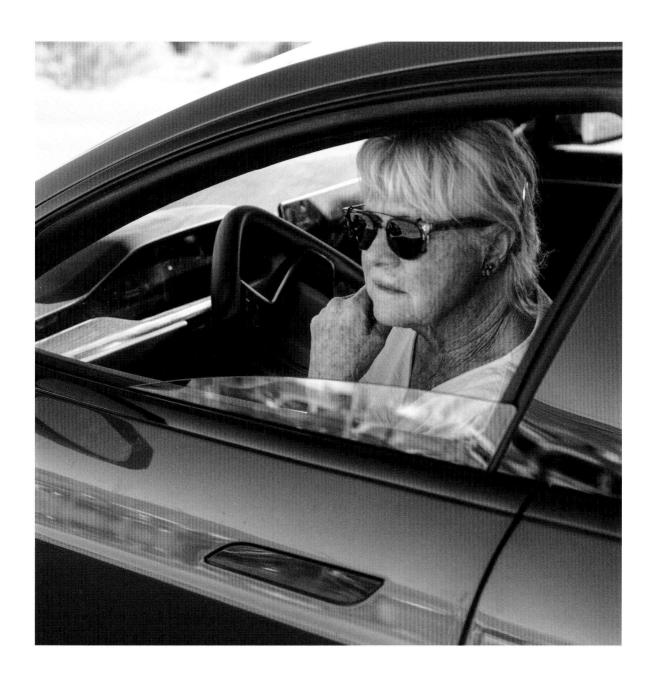

Nancy in her Tesla S

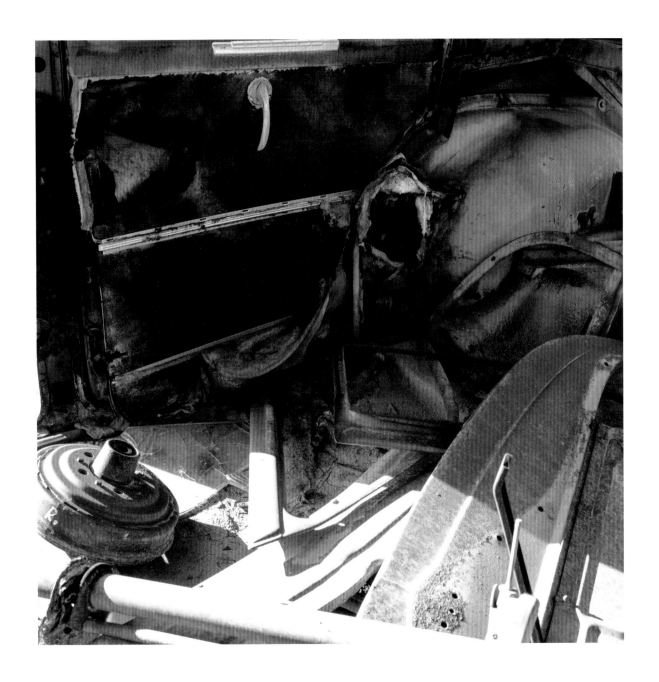

Interior 1950 Plymouth Special Deluxe

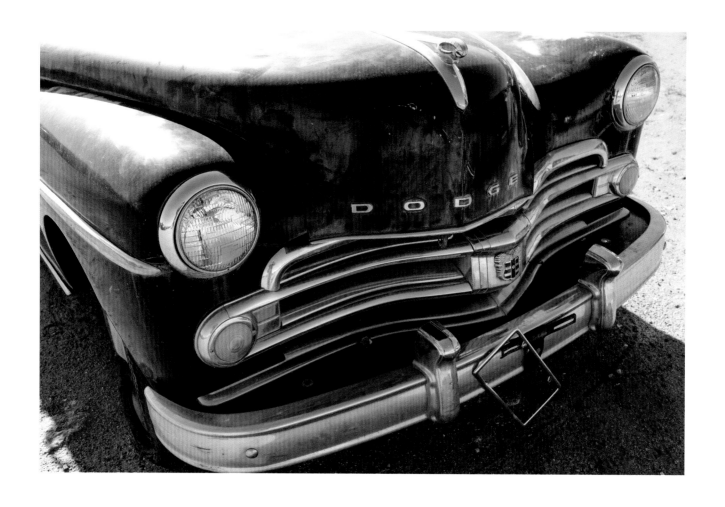

1950 Dodge Coronet

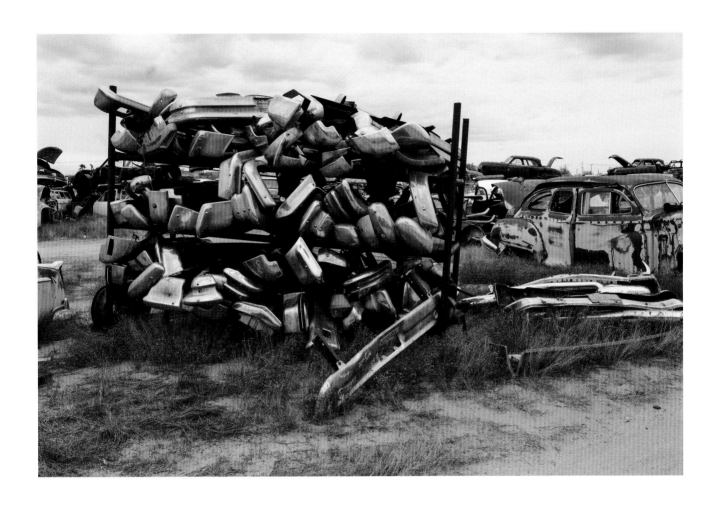

Shelves of Chrome Bumpers with 1948 Chrysler Windsor

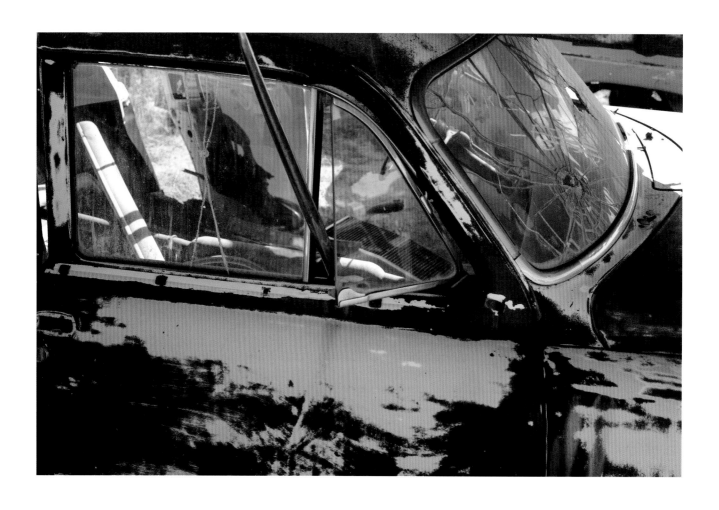

1954 Dodge Royal

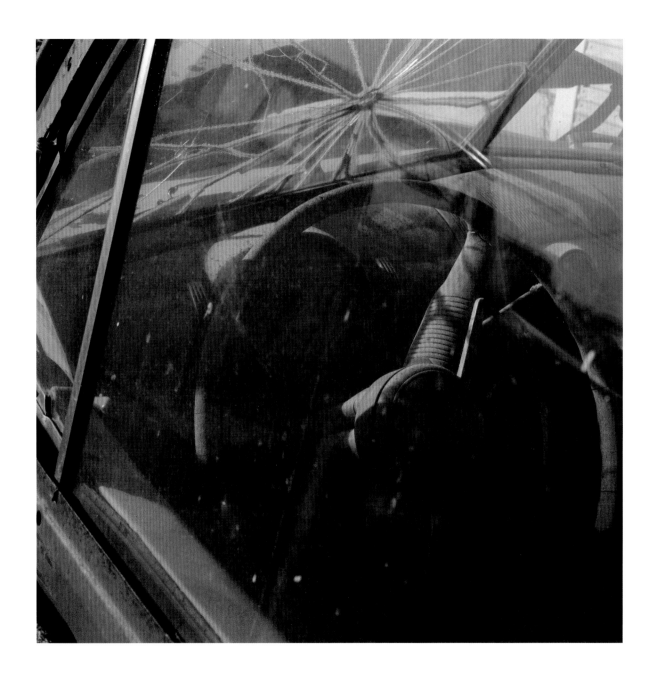

1949 Ford Club Coupe

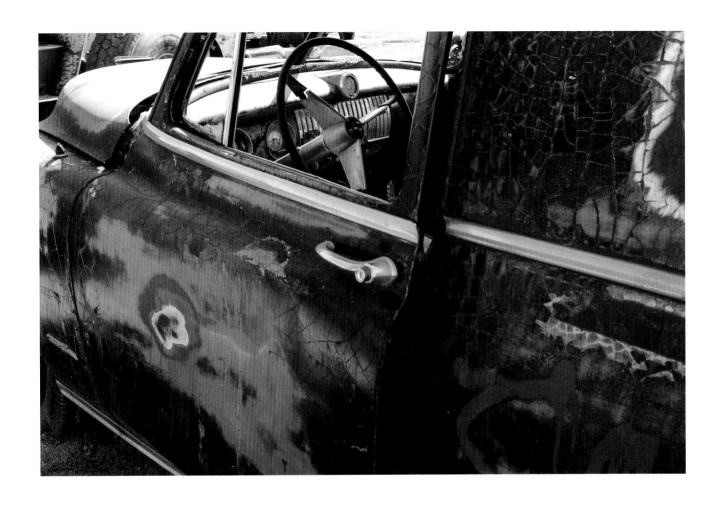

Early 1950s Chevrolet

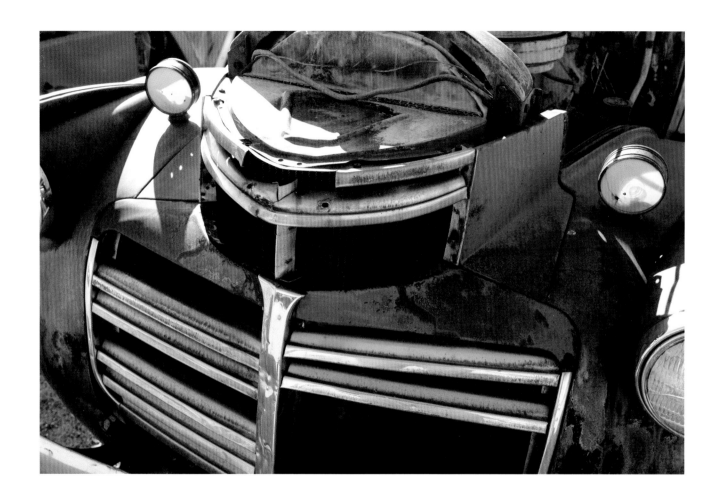

1940s GMC Truck

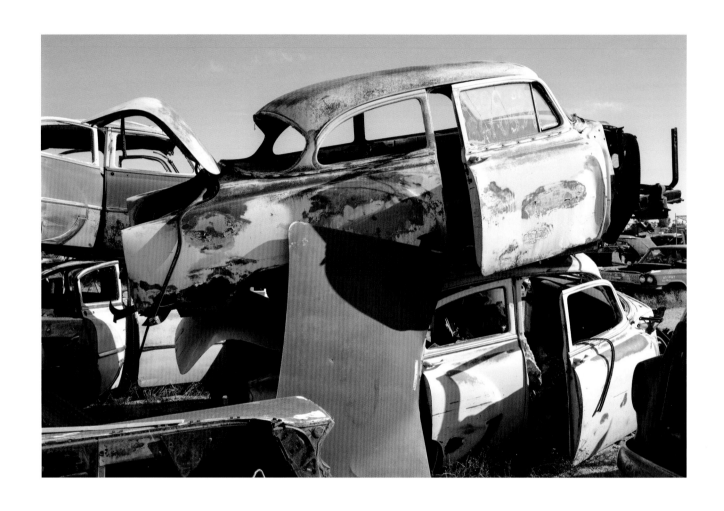

1953 Chevrolet 210

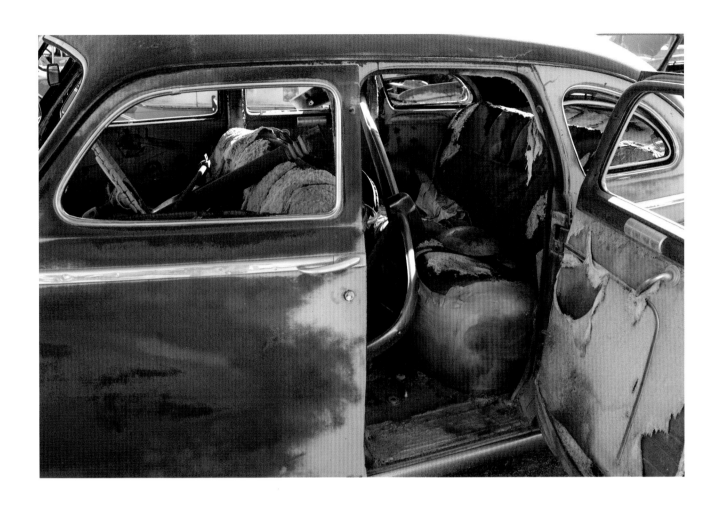

Early 1940s Plymouth Deluxe Four Door

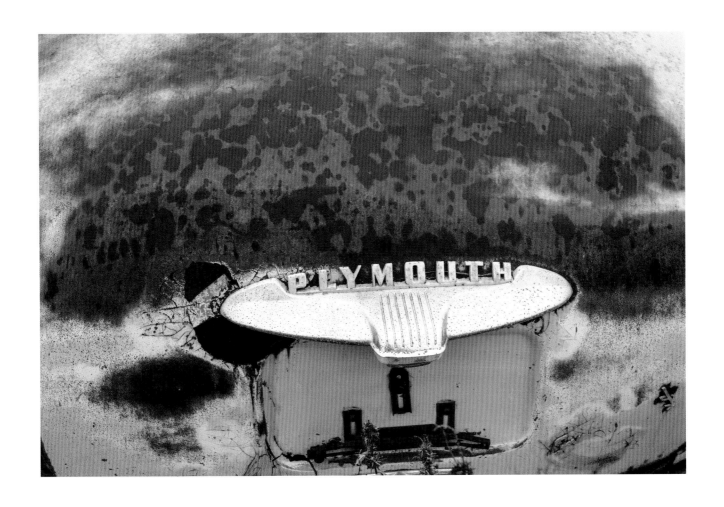

1952 Plymouth Cranbrook

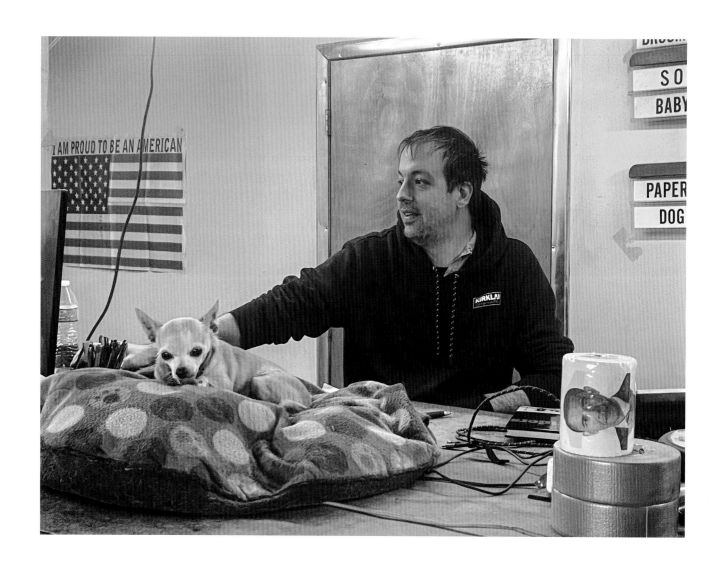

Oklahoma Junkyard Office. Dog with Presidential Toilet Paper. "It was a gift."

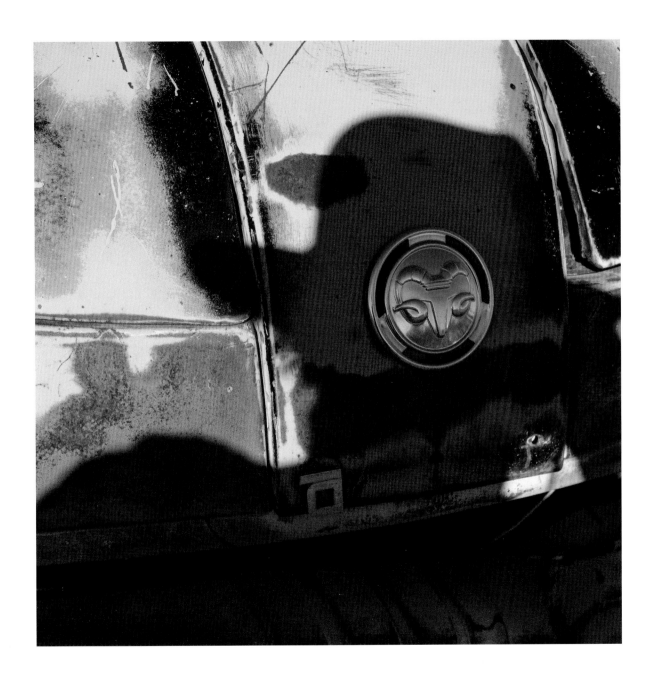

1954 Dodge Pickup

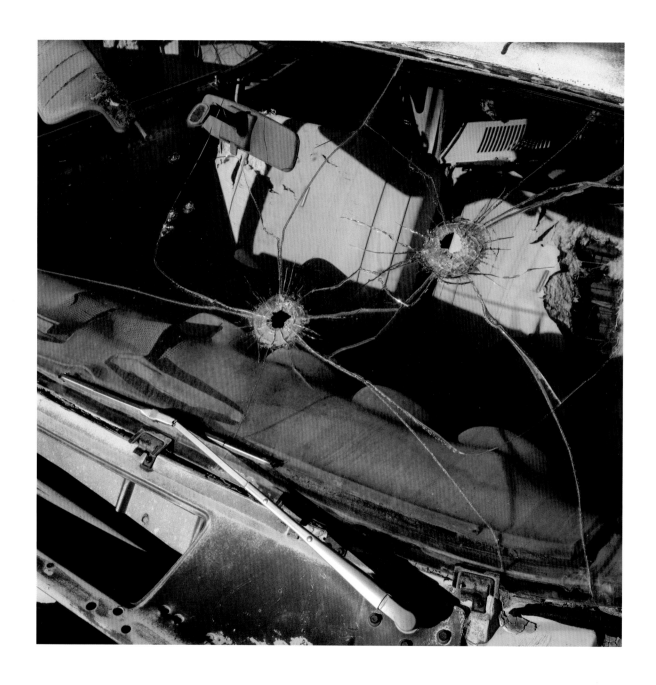

Shatterproof Windshield with Two Bullet Holes

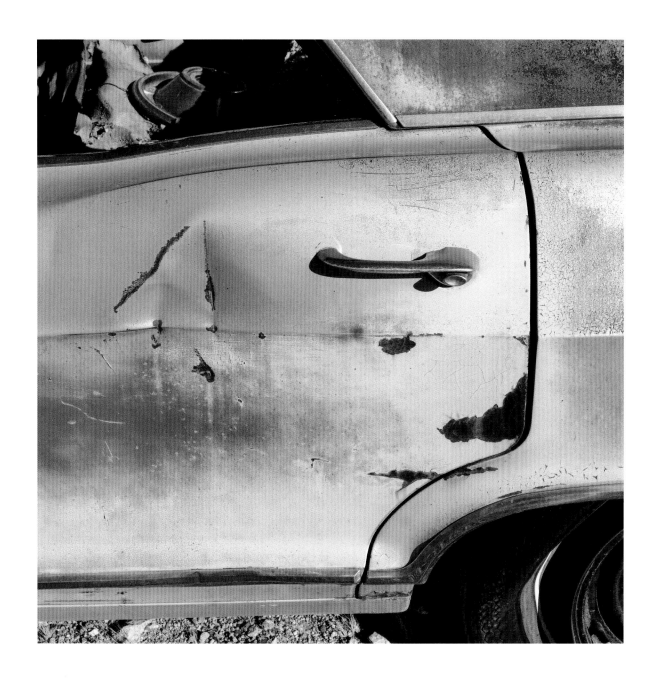

1965 Buick LeSabre

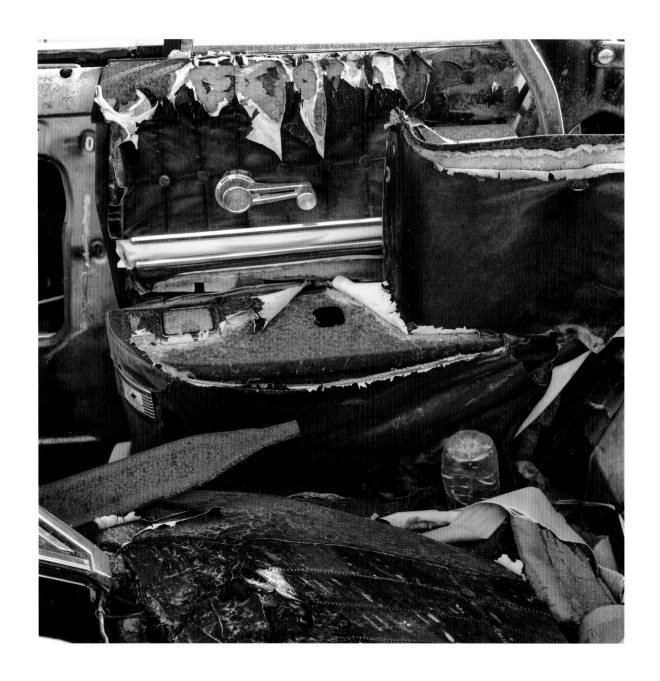

Interior 1960s Buick

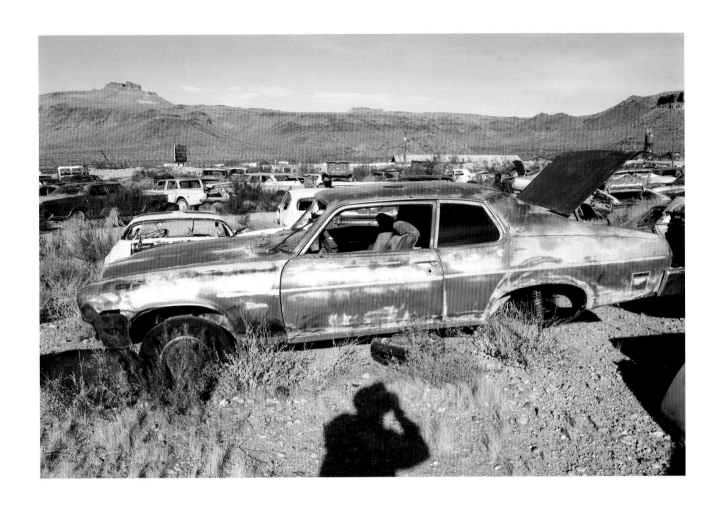

1971 Pontiac Ventura

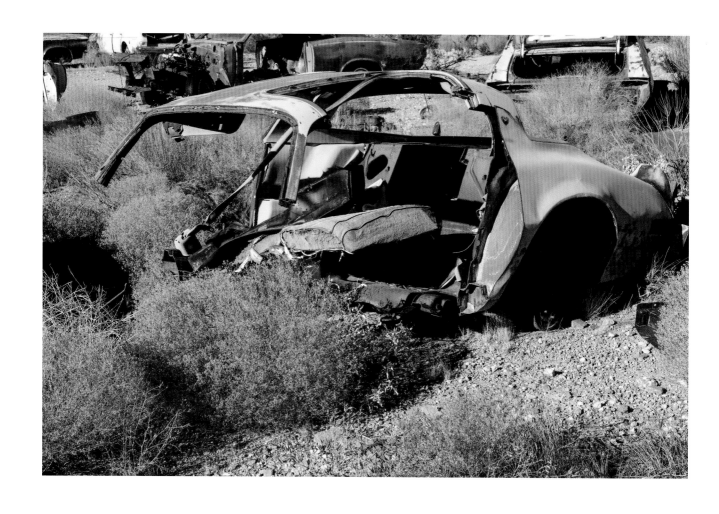

Late 1970s Pontiac Trans Am Shell

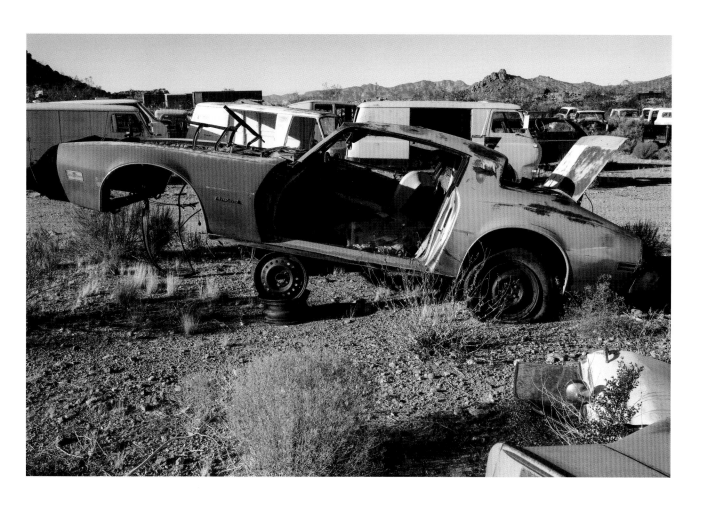

1970 Pontiac Firebird Coupe

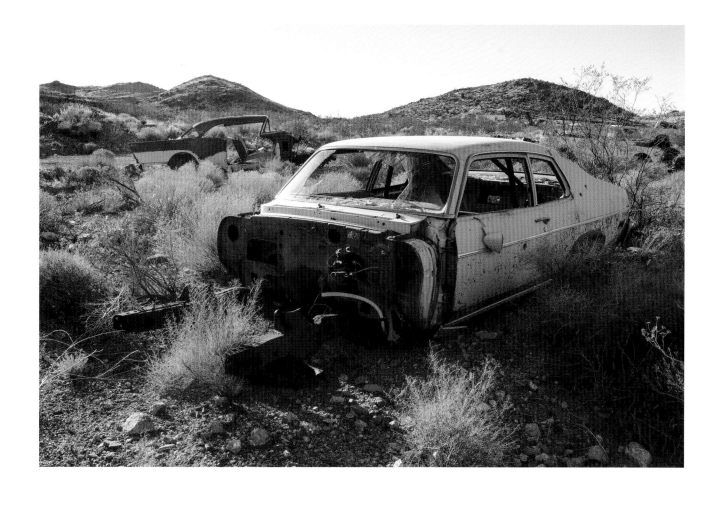

1973-1974 Chevrolet Nova

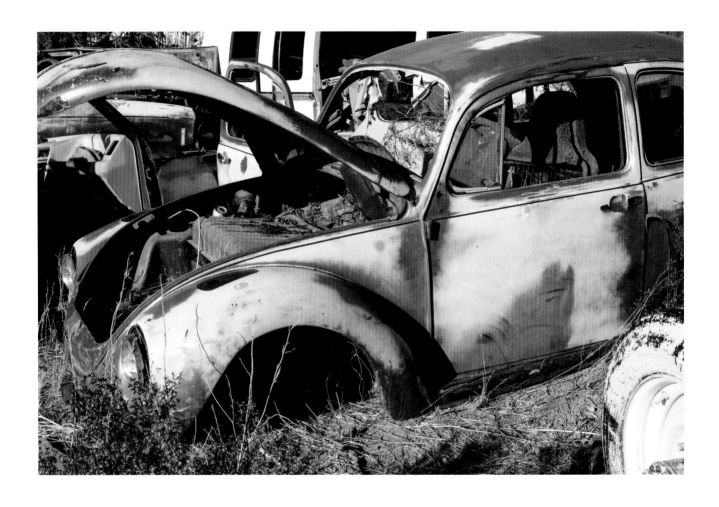

Volkswagen Fifth Generation Beetle (1974-1997)

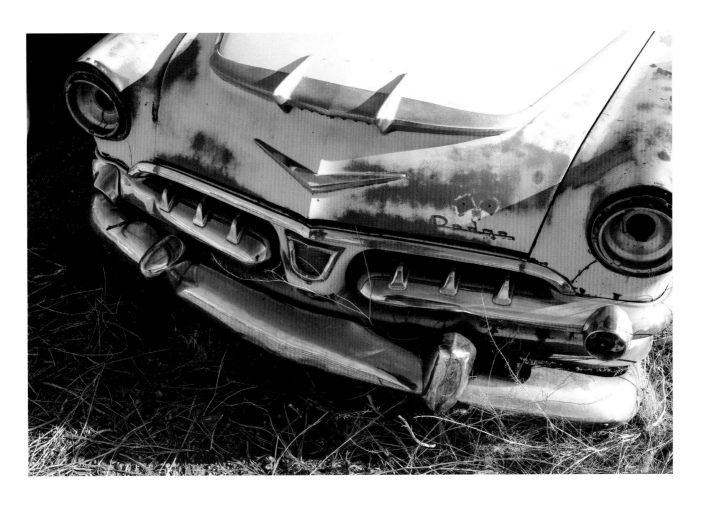

1956 Dodge Coronet

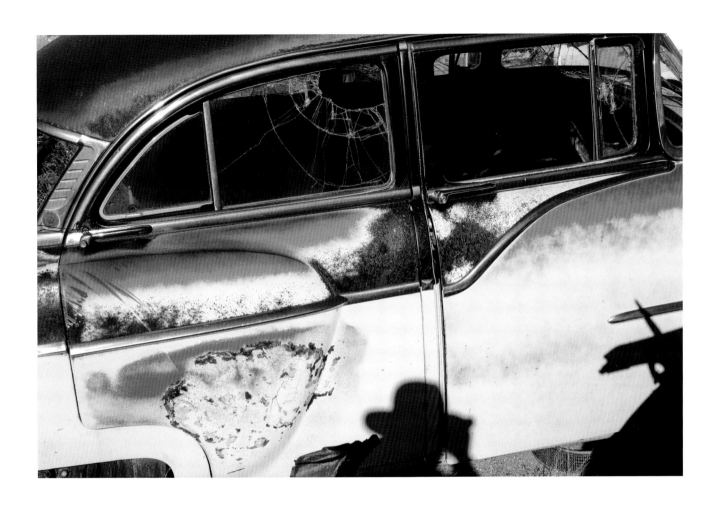

1955 Packard Super Clipper

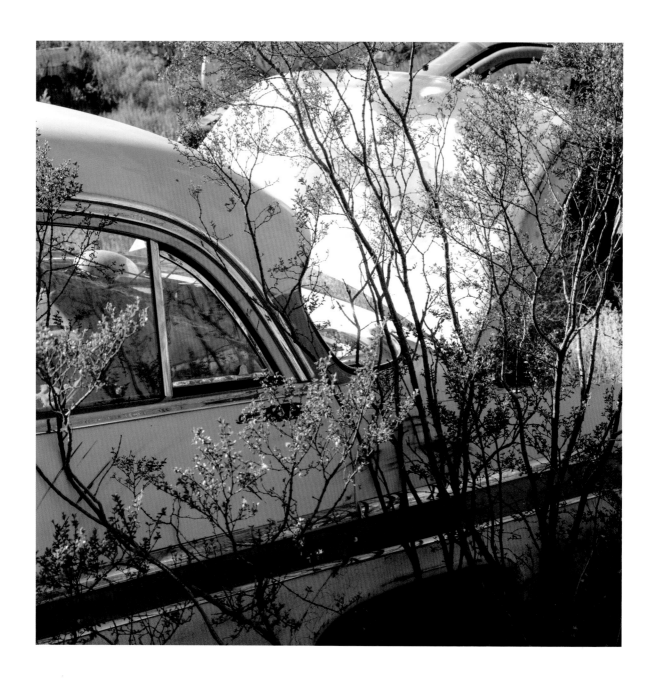

1955 Chrysler New Yorker

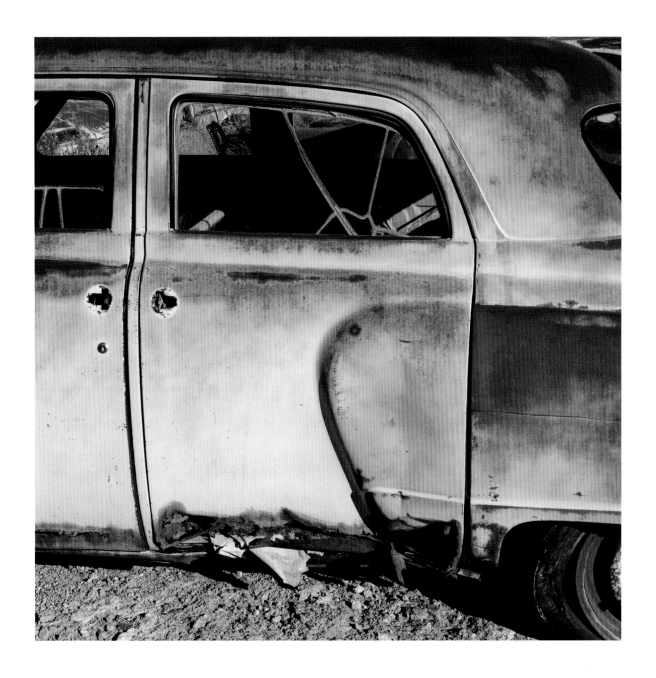

1952 Studebaker Champion Four Door Sedan

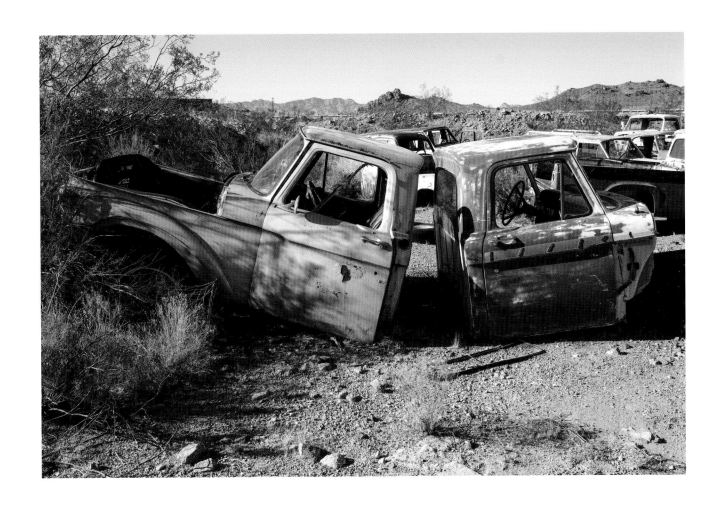

1964 and 1965 F-100 Truck Cabs

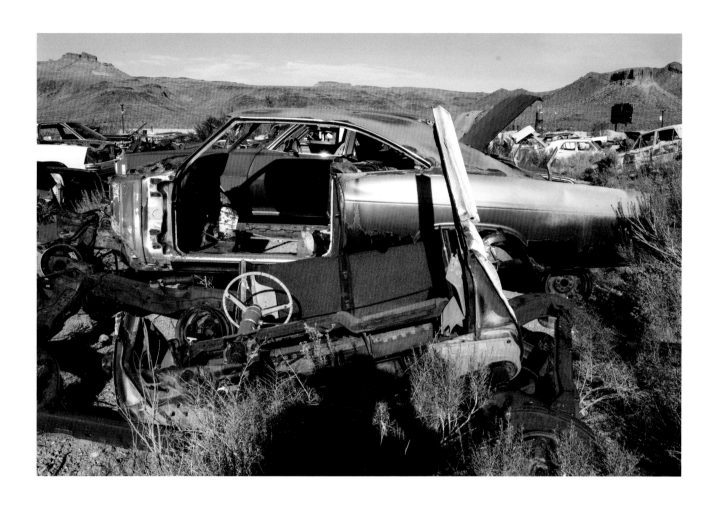

1966 Chevrolet Impala

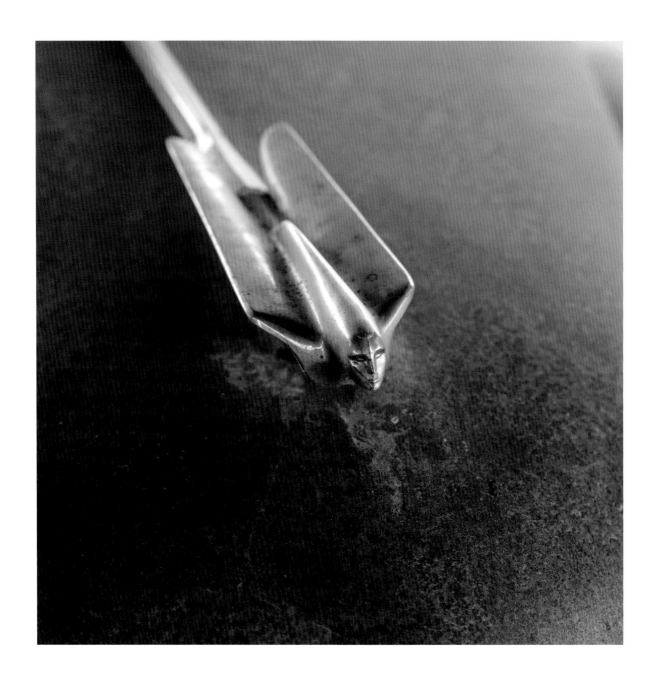

Early 1950s Cadillac

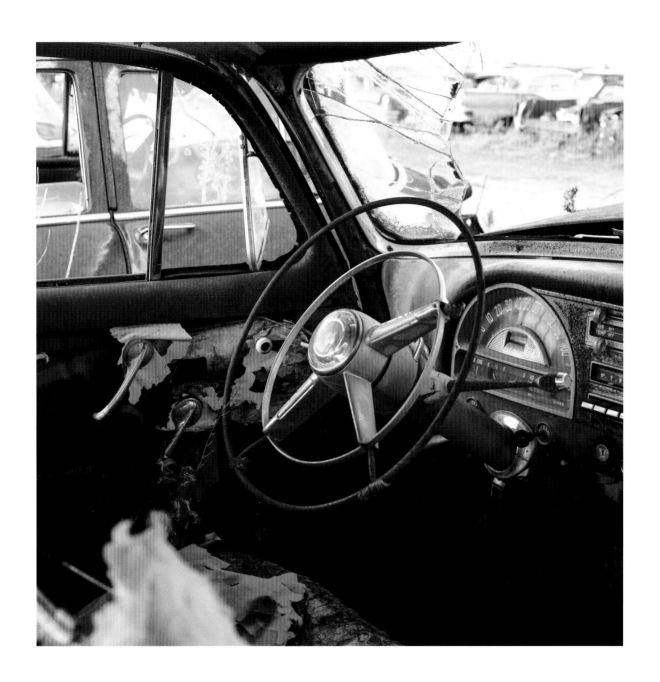

1954 Pontiac Chieftan

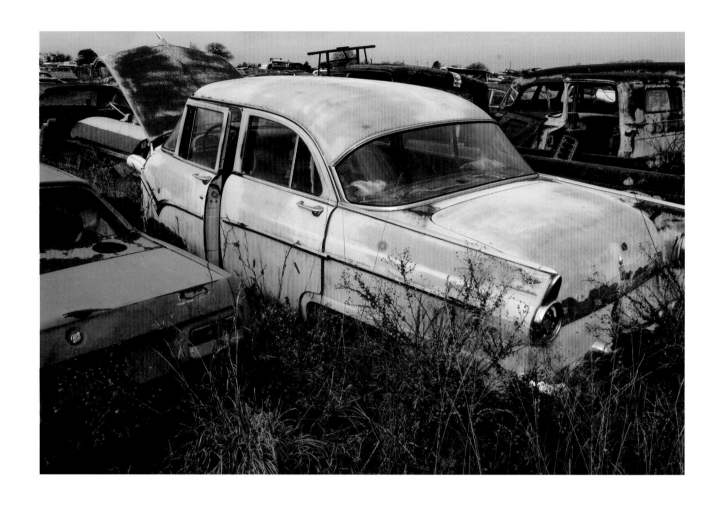

1955 Ford Fairlane

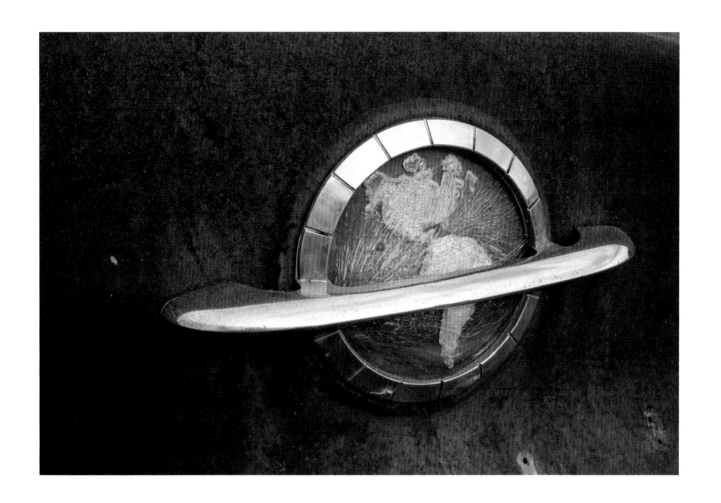

1954 Oldsmobile

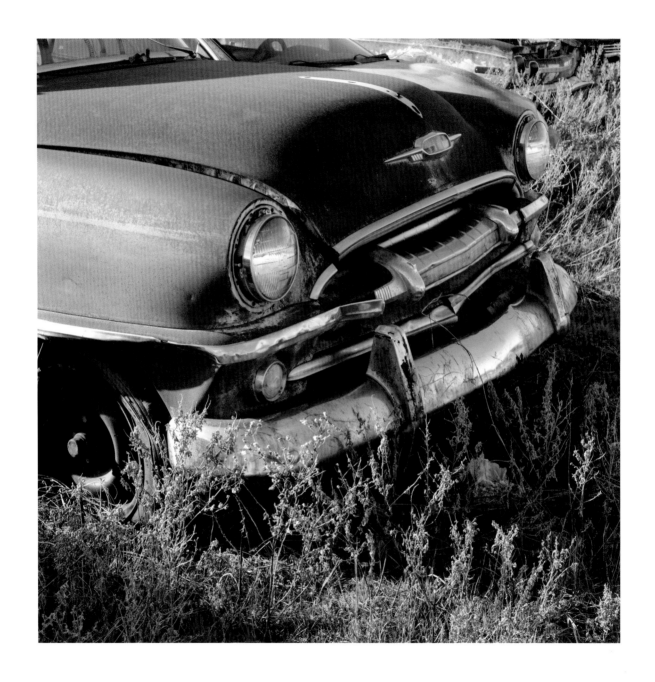

1954 Plymouth Belvedere

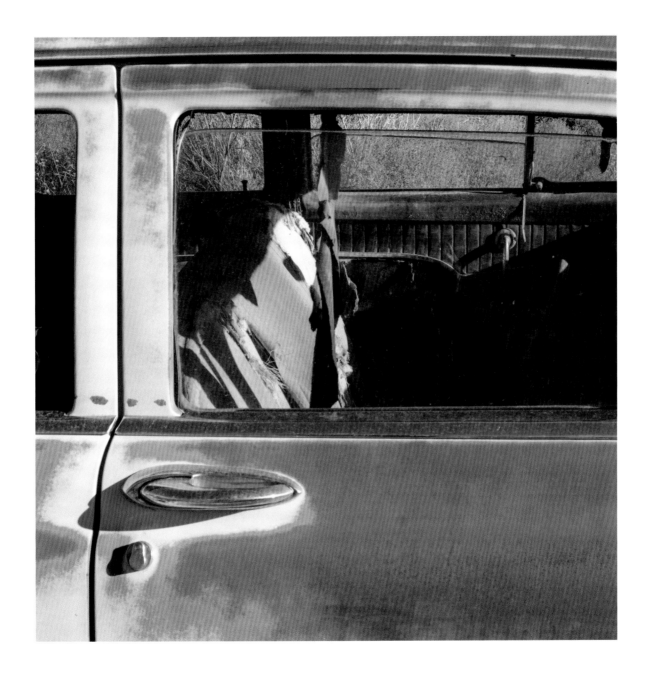

1953 DeSoto Firedome

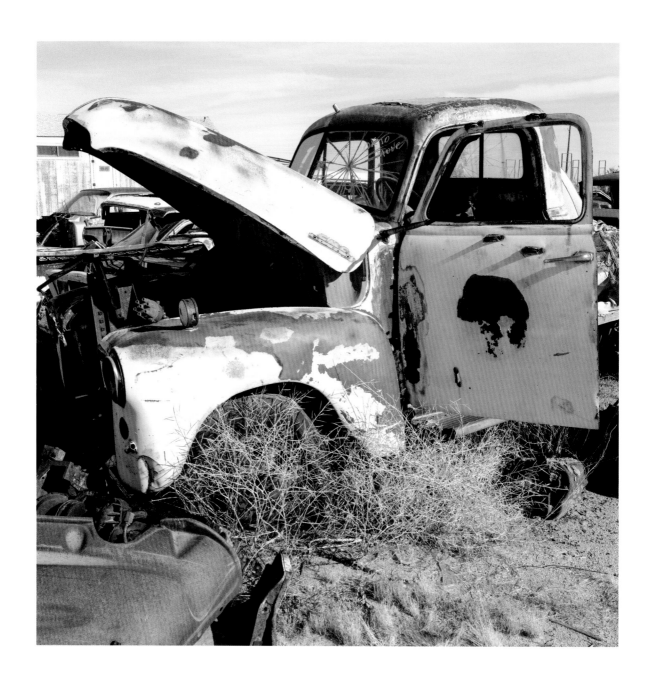

1951 GMC Pickup

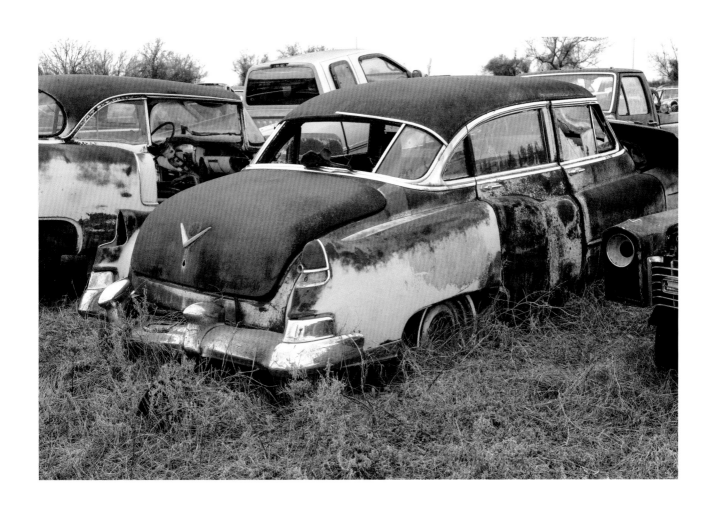

1951 Cadillac Series 61 Sedan

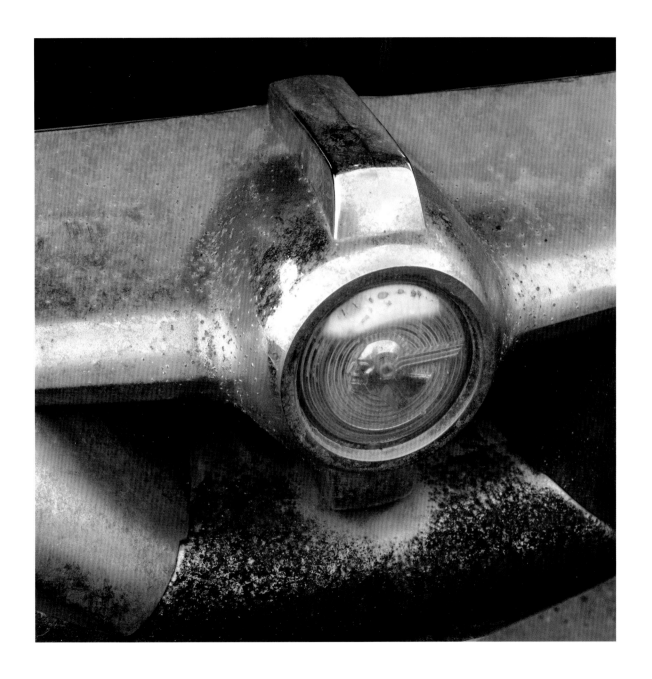

1951 Pontiac Chieftain

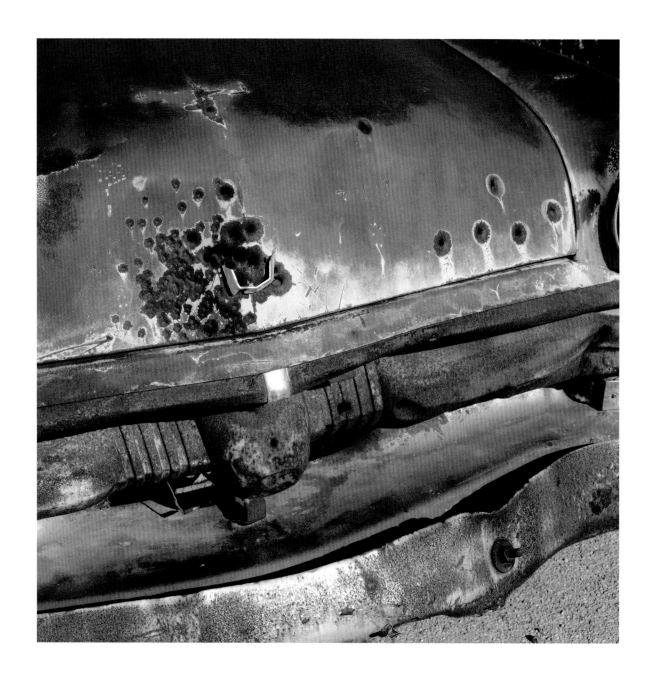

1953 Ford Customline

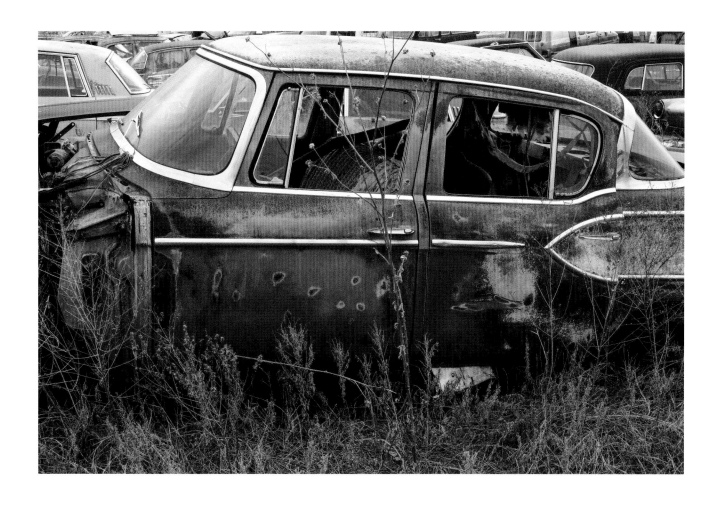

1957 Studebaker President

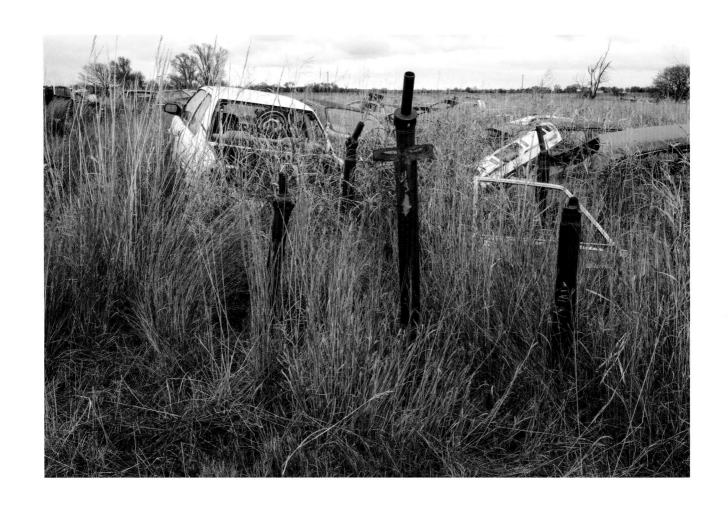

Three Drive Shafts

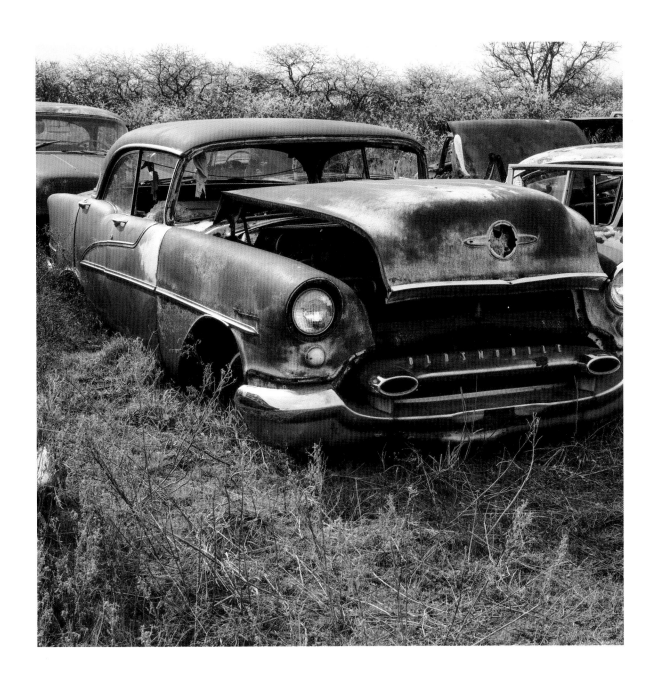

1955 Oldsmobile Holiday

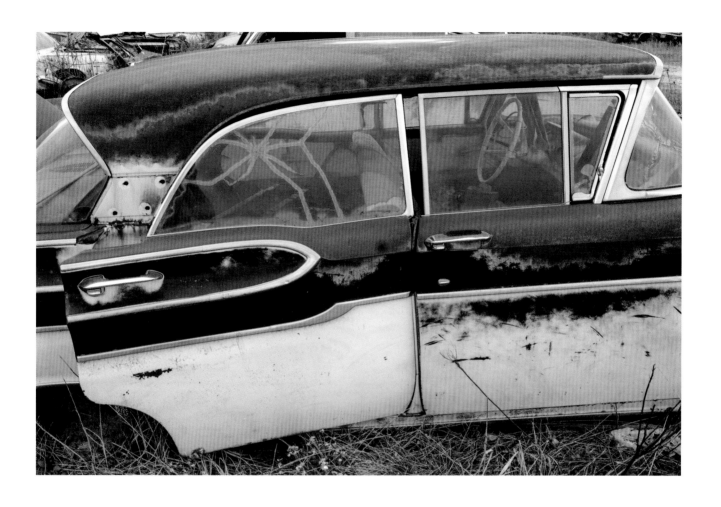

1957 Mercury Montclair

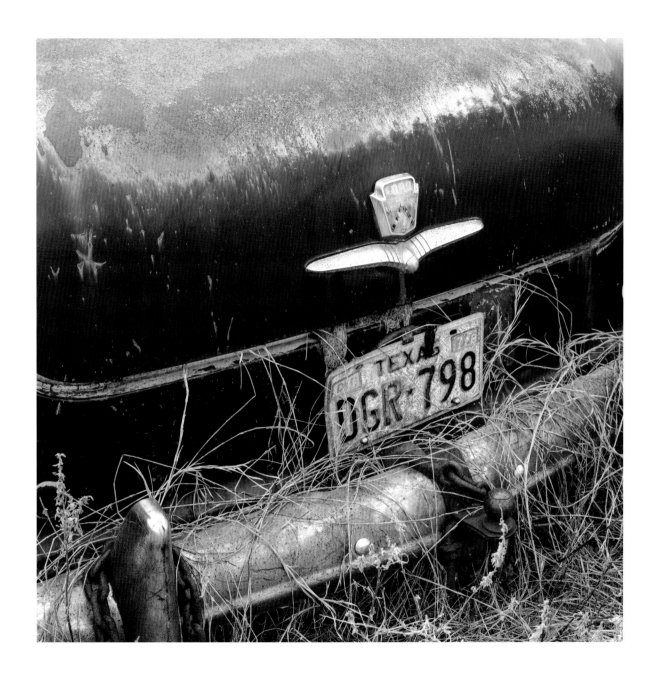

1953 Ford Customline

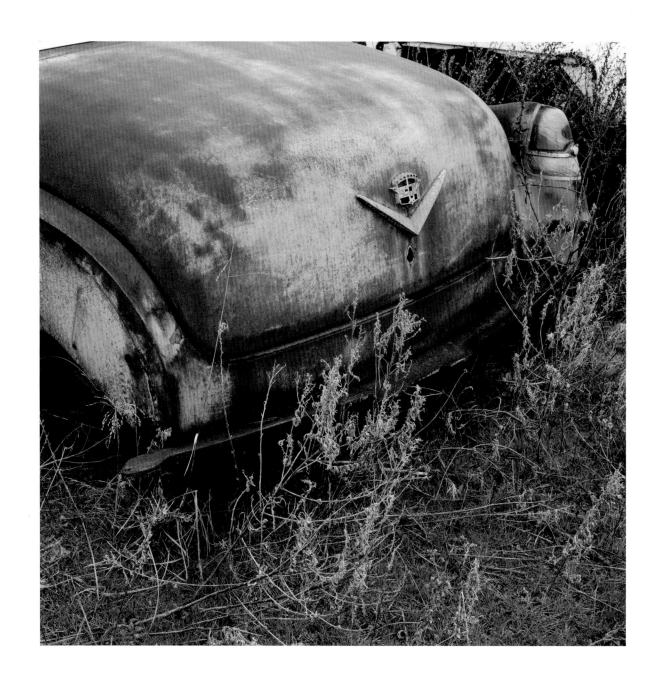

1952 Cadillac Series 62 Coupe

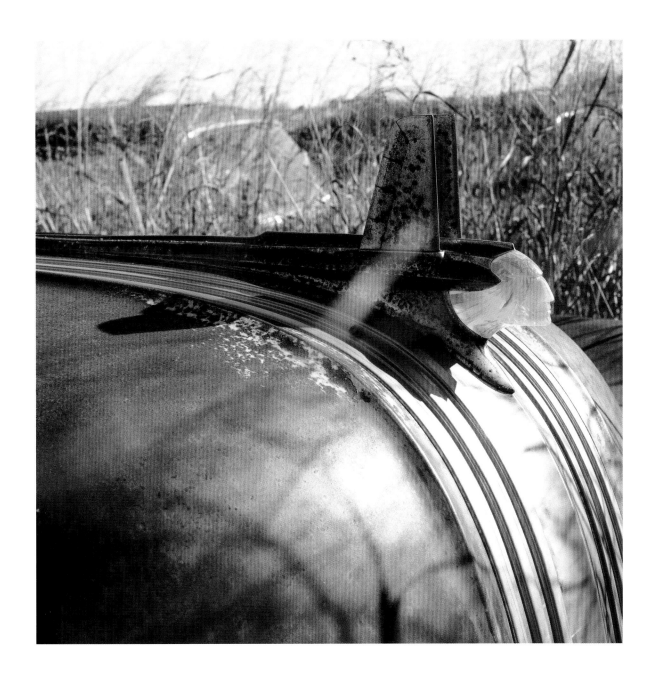

1953 Pontiac Chieftain Deluxe Eight Convertible

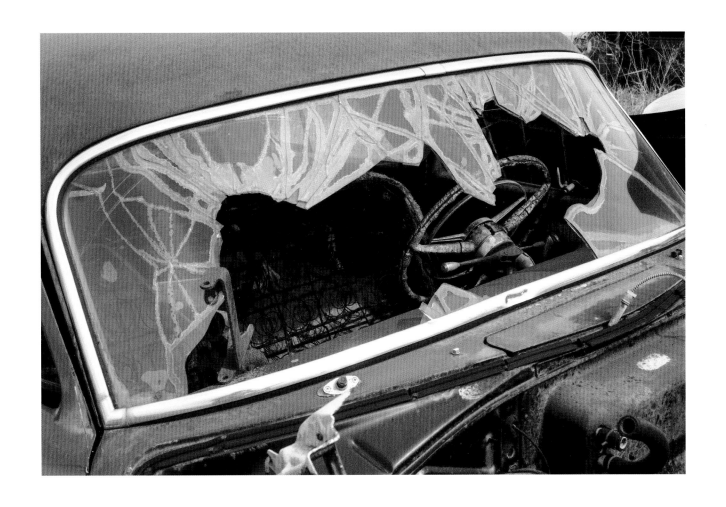

1953 Dodge Coronet

Biographies

Danny Lyon was born in Brooklyn, New York, in 1942 to immigrant parents, and raised in Queens. As a student at the University of Chicago he joined the Civil Rights Movement, becoming the first staff photographer for the Student Non-Violent Coordinating Committee (SNCC). A year after he left SNCC he joined the Chicago Outlaws Motorcycle Club and made his first book, The Bikeriders. Today Lyon is a photo-journalist, writer, and filmmaker. He was awarded a Guggenheim Fellowship in photography in 1969 and another in filmmaking in 1979. In 1990 he received a Rockefeller Fellowship in filmmaking and in 2011 the Missouri Honor Medal for Distinguished Service in Journalism. Lyon had a major retrospective, "Message to the Future," at the Fine Arts Museums of San Francisco and the Whitney Museum of American Art in New York in 2016. In 2022 he was inducted into the International Photography Hall of Fame. In 2023 his exhibition "Journey West - Danny Lyon" appeared in New Mexico at the Albuquerque Museum. Lyon has long been represented by Magnum Photos. His current gallery is the Howard Greenberg Gallery, New York City. Lyon is active on his blog at bleakbeauty.com, and at @dannylyonphotos2 on Instagram. All of his films are free to watch on vimeo.com/dannylyonfilms

Randy Kennedy is a writer, editor and curator. He was on the staff of The New York Times for 25 years, more than half of that time writing about the art world. His first novel, Presidio, was published by Simon & Schuster in 2018. He is currently director of special projects for the gallery Hauser & Wirth and editor-in-chief of the gallery's magazine, Ursula. He is the author of a new play, Red Gap, written in collaboration with the artist Will Boone.

ALSO BY DANNY LYON

THE BIKERIDERS

THE DESTRUCTION OF LOWER MANHATTAN

CONVERSATIONS WITH THE DEAD

THE AUTOBIOGRAPHY OF BILLY McCUNE

THE PAPER NEGATIVE

PICTURES FROM THE NEW WORLD

MERCI GONAIVES - HAITI AND THE FEBRUARY REVOLUTION

I LIKE TO EAT RIGHT ON THE DIRT - A CHILD'S JOURNEY BACK IN SPACE AND TIME

MEMORIES OF THE SOUTHERN CIVIL RIGHTS MOVEMENT

BUSHWICK, "LET THEM KILL THEMSELVES"

KNAVE OF HEARTS

INDIAN NATIONS

LIKE A THIEF'S DREAM

MEMORIES OF MYSELF

DEEP SEA DIVER

THE SEVENTH DOG

THE STORY OF SAM

BURN ZONE

AMERICAN BLOOD

JOURNEY WEST

THIS IS MY LIFE I AM TALKING ABOUT

FILMS

SOCIAL SCIENCES 127

THE DESTINY OF THE XEROX KID

LLANITO

EL MOJADO

LOS NIÑOS ABANDONADOS

LITTLE BOY

EL OTRO LADO

DEAR MARK

BORN TO FILM

WILLIE

MEDIA MAN (with Nancy Lyon)

TWO FATHERS

VIDEOS

FIVE DAYS (with Rebecca Lyon)

MURDERERS

SHADOWMAN

NOTHING

WANDERER

CHILDHOOD

SNCC

BEAT THE DRUM SLOWLY

Acknowledgements

JUNK began during a road trip with Nancy to the Pine Ridge, Oglala Lakota, Reservation where I was working on a book of Polaroid negative pictures which would eventually be published as Indian Nations. We were driving in Nebraska near the Wounded Knee Massacre site when we passed a farmer's field that had a collection of old American cars and trucks. After the farmer gave me permission, I photographed the vehicles with my Rolleiflex using color negative film. Those pictures are reproduced in this book with a thin black border. Twenty years later Nancy was driving her Tesla S which can go from zero to 60 in 1.8 seconds and reach 200 mph, when we were forced off Interstate 40 and onto old Route 66. Once again, we passed a small fenced field of old cars, which I was graciously allowed inside by a person named Leeann. This time I was carrying a medium format digital Fuji Flex. Anxious to find more cars we searched for yards in Oklahoma, Texas, Central Arizona and Northern Arizona. When we left the yard in the Oklahoma panhandle we drove through Washita, where Osage scouts (the heroes and victims of Scorsese's film) led the United States army to a peaceful Indian village where the 7th Cavalry murdered two hundred Cheyenne. The junk yards were not easy to find. Most of the large old cars have been crushed into cubes for their steel content which is substantial. Nancy, who has been my wife and companion for 48 years did all the driving. Without her I would have stopped years ago. Many thanks to the novelist Randy Kennedy with his deep roots in West Texas, who offered to write about the pictures, and to my assistant, Lacey Chrisco (also from Texas), who did a truly amazing job of identifying the cars, and pieces of cars. I want to thank my digital guru Blaise Koller and our oldest daughter, Gabrielle Lyon. Love and thanks to the team at Damiani, my designer Lorenzo Tugnoli and my publisher Eleonora Pasqui, that have made this, another new work possible. Grazie.

Danny Lyon

Danny Lyon
JUNK. America in Ruins

Published by Damiani
info@damianibooks.com
www.damianibooks.com

Printed in December 2024 by Lito Terrazzi, Italy.

ISBN 978-88-6208-832-9

MIX
Paper | Supporting
responsible forestry
FSC® C016466
FSC
www.fsc.org